REMBRANDT

Master Drawings

KEITH ROBERTS

PHAIDON **E.P. DUTTON**
Oxford New York

Phaidon Press Limited, Littlegate House, St. Ebbe's Street, Oxford
Published in the United States of America by E. P. Dutton and Co., Inc.

First published 1976

© *1976 by Phaidon Press Limited*
Text © *1976 by Keith Roberts*

ISBN 0 7148 1761 9
Library of Congress Catalog Card Number : 76–5362

Printed in Great Britain by
Well Hall Press Ltd., Bromley, Kent

REMBRANDT: MASTER DRAWINGS

First, a few facts about Rembrandt's life. He was born in Leyden in 1606, the son of a miller, Harmen Gerritsz. van Rijn, and his full name was Rembrandt Harmensz. van Rijn. In 1620 he began to study at Leyden University but apparently stayed for only a short period. His initial training as a painter seems to have been with Isaacsz. van Swanenburgh, a mediocre artist with whom he worked for about three years. This was followed by a more fruitful sojourn in Amsterdam, where he studied with Pieter Lastman for approximately six months. Lastman was a well known master, who had been in Italy and had been influenced by both Elsheimer and Caravaggio. Rembrandt is also said to have had a short spell in the studio of Jacob Pynas.

In 1625, Rembrandt set himself up in a studio in Leyden, where he prospered with a series of small-scale Biblical and historical scenes and, latterly, portraits. Probably as a result of the commission for *The Anatomy Lesson of Dr Tulp* (1632, The Hague, Mauritshuis), he settled in Amsterdam, where he was to live for the rest of his life. It was during the 1630s that Rembrandt enjoyed his greatest period of professional success and, probably, personal happiness. He married Saskia van Ulenborch (see Plates 10, 14, 15, 16, 17) and became the leading Dutch society portrait-painter of the day (see Plate 11). This phase of his life culminated in the so-called '*Night Watch*' (1642, Amsterdam, Rijksmuseum), the reception of which has led to a good deal of mythological embroidery over the centuries. But it does seem certain that it was not the success that Rembrandt must have hoped for; and from this point on he moved, by slow degrees, further and further away from the centre of conventional Dutch taste. His brushwork became freer, at a time when smoothness was fashionable, and his interpretations of Biblical and historical subjects increasingly personal and rugged just when an orthodox, classicizing style was in demand.

Rembrandt's personal affairs suffered a corresponding decline. Saskia died in 1642, the year after the birth of Titus, the only one of her children to survive beyond infancy (see Plates 50, 51, 52); and, in October 1649, he was accused of breach of promise by the former nurse of Titus. It is on this occasion that we first hear of Hendrickje Stoffels (see Plate 57), who lived with Rembrandt until her death in 1663. He had always lived extravagantly, and in 1656 he was declared bankrupt. An inventory of his possessions was made, and this throws a fascinating light on his collections and working methods. Later there was a sale of his possessions. In order to evade a harsh edict of the Painters' Guild of St Luke, affecting bankrupts, Titus and Hendrickje formed a company which received all Rembrandt's new works in return for free board and lodging.

Perhaps unfashionable, but certainly not forgotten (Cosimo de' Medici, later Grand Duke of Tuscany, went to his studio on a visit to Amsterdam in 1667), Rembrandt died at the age of sixty-three on 4th October, 1669, and was buried four days later in the Westerkerk.

Approximately 1,400 drawings by Rembrandt are known today, which certainly represent only a portion of the original total. We may deduce this by taking into

consideration weak copies of otherwise unrecorded sheets and by relating the drawings, in a general way, to the pictures. For example, there are no surviving studies for 'The Night Watch', although it is inconceivable that Rembrandt would have painted so important a work without making sketches, if only to give the sitters some idea of what to expect. On the other hand, there are several drawings for an *Adoration of the Magi* (British Royal Collection), which, in the event, Rembrandt did not paint himself. Anyone considering the drawings as a group, for the first time, may well be surprised by how few sketches there are for the large number of paintings and etchings that Rembrandt produced. Several of these sketches are reproduced here: Plate 2 is a direct and relatively elaborate study for an etching; Plate 12 is a rough sketch for *The Abduction of Ganymede* (1635, Dresden); while Plate 40 is a careful preliminary drawing for the main figure in an important oil painting of 1641. Although there are quite enough drawings to give a clear idea of Rembrandt's creative processes, the emphases, based as they must be on the quirks of survival, could be misleading.

There are several seventeenth-century artists of the highest calibre – Velázquez, Caravaggio and Vermeer immediately come to mind – who evidently did not value drawing, and by whom virtually no wholly authentic studies survive. With Rembrandt, as we have seen, the opposite is true. They exist in abundance and can be divided into obvious categories: illustrations of biblical and historical subjects (Plates 6, 22, 46), portraits (Plates 40, 61), studies of everyday life (Plates 18, 20, 25), landscapes (Plates 47, 48, 49), animal studies (Plates 37, 54), and so on. But there are so many of them, and so few related to concrete projects, that sooner or later we must try and explain what exactly their purpose was. Why did Rembrandt draw so much?

It is a very difficult question, susceptible to a variety of inter-related answers. Perhaps the easiest way to begin is to compare the landscape drawings, as a group, with the painted landscapes. Plates 47, 48, and 49 appear to be direct transcriptions from nature. The light is even and the skies are cloudless. The compositions are very simple, the mood is serene and the style naturalistic. The paintings of landscape, however, of which there are about a dozen authentic examples, are with one exception (the little *Winter Scene* of 1646 at Cassel) entirely different in mood and character. The lighting is dramatic, the skies overcast, even stormy, and the higher viewpoint takes in much more scenery, which is littered with bridges, obelisks and fanciful towers. The general effect is artificial, there is a strong suggestion of landscape manufactured within the confines of the studio.

We have, then, two separate approaches to nature; and they were dictated by Rembrandt's awareness of the distinction between what he wanted his paintings to be about, and what he thought drawing, as a medium, could achieve. One of the most obvious hallmarks of Rembrandt's paintings is the use of shadow, the contrast between light and shade (chiaroscuro), and it is a quality best suited to the richness and transparency of oil paint. It is rarely adopted in the drawings. *Jesus and his disciples* (Plate 7), which employs a painterly chiaroscuro, is a very elaborate study and may have been intended as an independent work of art in its own right, to be judged almost as if it were a painting.

An equally important feature of the paintings is the wealth of detail, the delight in texture and surface, wrinkles in the faces of the old, the gleaming threads in an ornamental robe. In the 1620s and the 1630s Rembrandt tended to paint such features objectively, as sober transcriptions of the model or object before him. The

4

world was, for him, a kind of still-life. But as he grew older, and his mastery strengthened and matured, technique and what was being portrayed seemed slowly to grow together, so that in the later masterpieces, *Jacob blessing the children of Joseph* (1656, Cassel), perhaps, or the portraits of Jacob and Margaretha Trip (*c.* 1660, National Gallery, London), the faces, clothing and accessories seem to take on some of the character of the very pigments with which they have been conjured into being. Skin, fur, satin: what is seen and the way it is seen have merged and become as one.

Such a style, where almost everything happens on the canvas in the course of painting, is bound to reduce preparatory drawing to a minimum, useful really only for fixing poses and the general composition. This is why there may never have been, in fact, quite as many preparatory studies as we might care to imagine.

Rembrandt, however, was shrewd enough to realize that the procedures of the studio, on which the quality and intensity of his painting depended, could not give him the tone of life, its cut and thrust, the unselfconscious currents of feeling that pass between people in their everyday dealings with each other, those imponderables that nourished his art quite as much as his love of rich textures and colour harmonies. And it was precisely at this point that the role of drawing came into its own. *The woman with a child frightened by a dog* (Plate 18) would not have been feasible, on its own special terms, as a seventeenth-century painting. The indifference to details of texture and surface and setting, to everything except the communication of human feeling through movement, gesture and expression, the crucial economy of style, which is inseparable from the point that Rembrandt wanted to make, would have been impossible in a finished oil painting. He looked at life through the medium of drawing, and at drawing as a medium, because it brought him something that was vital to his painting but which his studio method of work could not in itself provide.

Although Rembrandt would have claimed painting as his major medium, *the* medium, drawing was a genuine extension of his art and allowed him into areas of life and feeling that might not otherwise have been recorded. And because he had such marvellously sharp eyes, and that tender lack of scruple which permits great artists to push decorum aside, he has left us unforgettable images of his own private world: his home (Plate 16); his wife, Saskia, in sickness (Plate 14) and in health (Plate 10); Hendrickje, solace of his later years (Plates 57 and 60); and Titus (Plates 50, 51, 52), his son. It is hard to think of another drawing in European art that is at once so tender and so monumental as the study of Hendrickje asleep (Plate 57).

There is one category among Rembrandt's drawings which requires little basic explanation: the copies after other works of art. In the seventeenth century the only way to record what a picture or a piece of sculpture looked like was to obtain an engraving of it or make your own version. When he copied Leonardo da Vinci's *Last Supper* (Plate 27), Rembrandt was working not from the original (he never went to Italy) but from a mediocre, early sixteenth-century engraving of the fresco. Rembrandt was himself a great collector and he studied and copied the work of others in order to understand them and learn the formal secrets of their artistic power. And like all great copyists, from Michelangelo to Degas, Rembrandt subtly transformed his models, so as to bring them within his own stylistic terms of reference. The chief formal point about Leonardo's *Last Supper* is the perfect balance of the design, emphasized by a perspective that allows all the lines of recession to meet

in the head of Christ. But Rembrandt in the 1630s loved movement and asymmetry; and he quietly 'spoils' Leonardo's design by extending the canopy above Christ over three of the Apostles seated on the right side of the table.

Rembrandt was a great reader of the Bible; it is one of the central facts that we need to know about him. No one else has illustrated so many of its stories. One of the most curious features of the Bible, considered as literature, is the generalized, epic character of the style, which invariably 'states' rather than 'describes' a person or a place. There is no description in the Gospels of what Jesus Christ looked like. It was into the inspiring mould of the Bible stories, sublime in outline, weak in circumstantial detail, that Rembrandt was able to pour the liquid gold of his observation. The vividness of his Biblical scenes is unparalleled and unsurpassed. *The mocking of Christ* (Plate 46) and *Christ healing a sick woman* (Plate 58) have the directness of contemporary events. And that, in a sense, is what they are: Rembrandt's reading and his observation have grown together and become indistinguishable. And, once again, as in the *Woman with a child frightened by a dog* (Plate 18), the directness, the extraordinary – at times almost eerie – feeling of Our Lord's Life, caught, like any ordinary man's life, merely in passing, is a property not just of Rembrandt's observation alone, but of his talent operating through the swift, light medium of drawing. None of his great paintings of the 1650s, magnificent though they are in other respects, has the economy and *speed* of the *Christ healing a sick woman*. At the same time, masterpieces such as *The Apostle Peter denying Christ* (1660, Amsterdam, Rijksmuseum) or *The Conspiracy of Julius Civilis* (1661, Stockholm, Nationalmuseum), have a directness of emotional feeling, a psychological buoyancy, that ultimately depends on years of observation sharpened and refined by drawing.

The Plates

For the basic information on the drawings, medium, size, location, etc., as well as for many points of detail relating to the dating and the interpretation of the subject-matter, I am indebted to the standard work: *The Drawings of Rembrandt* by Otto Benesch. This monumental work, in six volumes, was originally published by Phaidon Press between 1954 and 1957. A revised edition, incorporating further drawings accepted by the author, and additional notes that he had made, was prepared by Mrs Eva Benesch and published in six volumes in 1973. The numbers in square brackets refer to catalogue entries in the second edition.

Plate 1. *Old man with his arms extended.* About 1629. Black chalk, 25·4 × 19 cm. Dresden, Kupferstichkabinett. [Be. 12]

A powerful early drawing that can be related to a number of etchings of beggars made about 1628–9.

Plate 2. *Diana at the bath.* About 1630–1. Black chalk, washed with bistre, 18·1 × 16·4 cm. London, British Museum. [Be. 21]

A preparatory drawing in reverse for the etching; the lines in the drawing are indented partly with a stylus, partly with hard black chalk, for transfer to the plate. The etching, for which this is a careful study, had already become in the seventeenth century a celebrated example of Rembrandt's anti-classical attitude to art. Jan de Bisschop, in a volume published in 1671 and dedicated to Rembrandt's old patron, Jan Six, attacked the idea of painting a Leda or a Danaë with fat belly, sagging breasts and garter marks on her legs. The attack was renewed by Samuel van Hoogstraten in 1678 but although, like Jan de Bisschop, he was influenced by the example of Rembrandt's etchings, the artist himself was not specified. Only in 1681, when Andries Pels wrote a poem entitled *The Use and Abuse of the Theatre*, was Rembrandt's name mentioned. Pels branded him 'the first heretic in the art of painting', and accused him of using as models 'a washerwoman or treader of peat from the barn'.

Plate 3. *Study for Lot drunk.* Signed and dated 1633. Black chalk, slightly touched with white chalk, 25·1 × 18·9 cm. Frankfurt, Städelsches Kunstinstitut. [Be. 82]

This powerful drawing is directly related to a lost early Rembrandt painting, whose composition is recorded in a 1631 etching by J. G. van Vliet. Although in the picture Lot is animated and raises his empty cup aloft, in contrast to the lassitude of the drawn figure, the costume and type are identical. The same old man also appears in other early paintings by Rembrandt: *The Prophet Jeremiah mourning over the destruction of Jerusalem* (1630; Amsterdam, Rijksmuseum); *The Apostle Peter in prison* (1631; Private Collection, Brussels); *The Apostle Paul at his desk* (Nuremberg).

Plate 4. *Study for Jacob lamenting at the sight of Joseph's blood-stained coat.* About 1635. Pen and bistre, wash, 17·2 × 15·5 cm. Berlin, Kupferstichkabinett. [Be. 95]

During the early 1630s, Rembrandt was preoccupied with a series of Old Testament subjects treated in the most vivid and dramatic terms that he could devise. *The*

feast of Belshazzar (1634–5; National Gallery, London) and *The blinding of Samson* (1636; Frankfurt) mark the climax of the series. Although only a rapid sketch, Plate 4 reveals a similar interest in strong emotion expressed by means of gesture, twisted movement and facial expression.

Plate 5. *The angel departs from Manoah and his wife.* About 1639. Pen and bistre, wash, 14·5 × 15·6 cm. Paris, Louvre. [Be. 179]

This spirited study illustrates a story to which Rembrandt returned on other occasions, notably in the great series of drawings of the mid-1650s for a painting (now in Dresden) which was, in the event, executed by a pupil. It comes in the Book of Judges (xiii) and describes how Manoah and his wife, the parents of Samson, 'took the kid with the cereal offering, and offered it upon the rock to the Lord, to him who works wonders. And when the flame went up toward heaven from the altar, the angel of the Lord ascended in the flame of the altar while Manoah and his wife looked on; and they fell on their faces to the ground.' The design of Plate 5 is connected with a painting of a rather similar subject: the 1637 *Angel leaving Tobias and his Family* (Louvre).

Plate 6. *The raising of the daughter of Jairus.* About 1632–3. Pen and bistre, 18·8 × 24 cm. Formerly Rotterdam, F. Koenigs Collection. [Be. 61]

A particularly expressive, early example of Rembrandt's ability to see Bible stories in terms of everyday life: look at the way in which the doctor bends over the girl, noting the last breath of life. This drawing is also typical of Rembrandt's general approach to subject-matter: the dramatic action is always more important than the setting.

Plate 7. *Jesus and his disciples.* Signed and dated 1634. Black and red chalk, pen and bistre, washes in different tones, heightenings in gouache, 35·5 × 47·6 cm. Haarlem, Teyler Museum. [Be. 89]

The unusual size of the sheet, the elaborate technique and the care taken over the execution (the disciple in the middle is drawn on a separate piece of paper, which was superimposed by Rembrandt himself) suggest that this may have been intended as an independent work of art rather than as a preparatory drawing for a picture or an etching. This is also one of the few drawings in which the contrasts between light and shade are as richly worked out as in a painting.

Plate 8. *The pancake woman.* About 1635. Pen and bistre, 10·7 × 14·2 cm. Amsterdam, Rijksprentenkabinet. [Be. 409]

This sketch, which probably dates from the same time as the 1635 etching known as *The pancake woman*, shows Rembrandt's keen yet affectionate eye for the small change of everyday life.

Plate 9. *Young woman having her hair plaited.* About 1632–4. Pen and bistre, washes in bistre and Indian ink, 23·8 × 18·4 cm. Vienna, Albertina. [Be. 395]

If this superb drawing does represent Rembrandt's wife, Saskia, as is often supposed, it probably dates from after their marriage in June 1634 (see note to Plate 10). But there is a second possibility, that it is a preparatory study for the painting in Ottawa of 1632–3 which is now interpreted as *Esther preparing to intercede with Ahasuerus*.

Plate 10. *Portrait of Saskia in a straw hat.* Dated 1633. Silver-point on white prepared vellum, 18·5 × 10·7 cm. Berlin-Dahlem, Kupferstichkabinett. [Be. 427]

The inscription, in Rembrandt's hand, is later than the drawing: 'this is drawn after my wife, when she was 21 years old, the third day after our betrothal – the 8th of June 1633.'

Plate 11. *Portrait of a man in an arm-chair.* Signed and dated 1634. Red and black chalk, pen and wash, on vellum, 37·3 × 27·2 cm. New York, Mrs Charles S. Payson. [Be. 433]

This is the most elaborately finished of all Rembrandt's surviving portrait studies, and would have been intended as a work of art in its own right. The sitter has been tentatively identified as Maurits Huygens (1595–1642), who in 1624 succeeded his father as Secretary to the State Council of the United Provinces. He was painted by Rembrandt in 1632 (Hamburg, Kunsthalle).

Plate 12. *The Abduction of Ganymede.* 1635. Pen and wash, 18·3 × 16 cm. Dresden, Kupferstichkabinett. [Be. 92]

A study for the painting of 1635, also in Dresden. The subject, from Greek mythology, shows Ganymede, who was the most beautiful of mortals, being carried off by Zeus, disguised as an eagle. He was taken to Olympus, where he became cup-bearer to the gods. Rembrandt treats the subject naturalistically; Ganymede is simply a frightened boy. This interpretation of the theme was probably inspired by the scenes of everyday life, such as *The naughty boy* (Plate 13), that he regularly recorded.

Plate 13. *The naughty boy.* About 1635. Pen, wash, white body colour and chalk, 20·6 × 14·3 cm. Berlin, Kupferstichkabinett. [Be. 401]

A brilliant example of Rembrandt's powers of observation and quickness of eye. Although he had four children by his marriage to Saskia, this was not one of them. The first three, a boy and two girls, all died within weeks of their birth. Titus, who did survive (see Plates 50, 51, 52) beyond childhood, was not born until 1641; and this drawing must date from several years earlier.

Plate 14. *Sick woman lying in bed* (probably Saskia). About 1635. Pen, wash and white body-colour, 16·3 × 14·5 cm. Paris, Petit Palais (Dutuit Collection). [Be. 283]

Plate 15. *Two studies of Saskia asleep in bed.* About 1635. Pen and brush, 13 × 17·1 cm. New York, Pierpont Morgan Library. [Be. 289]

Plate 16. *Saskia's lying-in room.* About 1639. Pen and wash, heightened with white, 14·3 × 17·6 cm. Paris, Fondation Custodia (F. Lugt Collection). [Be. 426]

Plate 17. *Saskia asleep in bed.* About 1635. Pen and bistre, 9·9 × 9·5 cm. Brussels, Musée des Beaux-Arts (Collection de Grez). [Be. 287]

Saskia van Ulenborch was born in 1612 and came from a well-to-do family; her father was burgomaster of Leeuwarden in Friesland. She must have met Rembrandt while he was living in the Amsterdam house of her cousin, Hendrick van Ulenborch, who was an art dealer. The couple were betrothed in June, 1633 (see Plate 10), and were married in June, 1634. Saskia brought Rembrandt a large dowry, and after her death in June, 1642, her estate was valued at more than 40,000 guilders. By the terms of her will, Rembrandt was to forfeit half of the estate should he remarry, a condition that was to complicate his life in later years when, in a less prosperous period, he formed a liaison with Hendrickje Stoffels (see Plates 57 and 60).

Saskia's health was probably not good. Plate 14 would seem to show her during an illness. Plate 16 may record one of her pregnancies.

Plate 18. *Woman with a child.* About 1636. Pen and bistre, 18·4 × 14·6 cm. Budapest, Museum of Fine Arts. [Be. 411]

Another of Rembrandt's brilliant studies of everyday life, probably based on the observation of his neighbours.

Plate 19. *The Virgin and Child seated near a window.* About 1635. Pen and bistre, plus wash, 15·5 × 13·7 cm. London, British Museum. [Be. 113 recto]

A comparison with Plates 18 and 20 shows how Rembrandt's religious imagery was nourished by his observation of contemporary life. This is also evident in the etchings and paintings (for example, the 1646 *Adoration of the Shepherds* in the National Gallery, London).

Plate 20. *Two women teaching a child to walk.* About 1637. Red chalk, 10·3 × 12·8 cm. London, British Museum. [Be. 421]

Plate 21. *Group of musicians listening to a flute player.* About 1635. Pen and wash, 13·5 × 15·4 cm. Formerly Donnington Priory, Berkshire, Gathorne-Hardy Collection. [Be. 399]

The man in the floppy hat playing the flute reflects the influence of Utrecht School painters such as Hendrick ter Brugghen (1588(?)–1629), whose somewhat flamboyant imagery impressed Rembrandt, especially in the early 1630s when his own paintings were at their most richly ostentatious.

Plate 22. *The Prodigal Son with the loose women.* About 1642–3. Pen and wash, 17·7 × 21 cm. Basle, Dr h.c. Robert von Hirsch. [Be. 529]

A drawing in the same spirit as Plate 21, although the pen work is richer and bolder.

Plate 23. *Sheet of studies.* About 1636. Pen and wash, and red chalk, 22 × 23·3 cm. Birmingham, Barber Institute. [Be. 340]

One of Rembrandt's most brilliant drawings as well as a telling index of his interests. The sketches of the mother and child show his concern with everyday life, directly observed, while the studies of heads in caps and turbans suggest his love of richness, appearance transformed by a judicious use of ornament.

Plate 24. *Two sailing-boats at anchor.* About 1636. Black chalk, 14·5 × 16·2 cm. Vienna, Albertina. [Be. 468]

Although landscape already appears in the backgrounds of his paintings in the late 1620s and early 1630s, Rembrandt did not become interested in nature for its own sake until the mid-1630s. The first dated landscape – and even this illustrates a biblical episode in the foreground – is the *Landscape with the Baptism of the Eunuch* of 1636 (Hanover).

Plate 25. *Two butchers at work.* About 1635. Pen and bistre, 14·9 × 20 cm. Frankfurt, Städelsches Kunstinstitut. [Be. 400]

This study is a useful reminder of Rembrandt's keen curiosity about every aspect of life. The slaughtered ox was the subject of two paintings, one in Glasgow (late 1630s), and the more famous panel in the Louvre, which is signed and dated 1655.

Plate 26. *Two negro drummers mounted on mules.* About 1637–8. Pen and wash in bistre, coloured with red chalk and yellow water-colour, heightened with

white, and some oil colour, 22·9 × 17·1 cm. London, British Museum. [Be. 365]

As Benesch has pointed out, 'Rembrandt made several sketches after a pageant with Africans and mummers which may have taken place in Amsterdam in 1637. J. Q. van Regteren Altena suggests a more definite date, February 1638, when Rembrandt could have observed such groups in the pageant of the tournament from the home of Constantijn Huygens in The Hague.'

Plate 27. *The Last Supper* (after Leonardo da Vinci). About 1635. Red chalk, 36·5 × 47·5 cm. New York, Metropolitan Museum of Art (Robert Lehman Collection). [Be. 443]

Rembrandt was both a collector and a great copyist of works of art. This sketch was based on a feeble Milanese engraving after Leonardo's fresco in S. Maria delle Grazie, Milan; and Rembrandt first made a rather careful copy, which he then went over in bolder and heavier strokes of the chalk. The earlier version is clearly visible, for example, in the figure of Christ. The two main features of Leonardo's masterpiece that must have attracted Rembrandt were the brilliance of the composition, with the twelve Disciples arranged in four groups of three, and the variety of the gestures and expressions. Rembrandt was particularly concerned with both problems in the mid-1630s, when he was painting life-size compositions of Old Testament subjects (e.g., *The Feast of Belshazzar*, about 1634–5, National Gallery, London). He has modified Leonardo's strict symmetry by introducing an off-centre canopy behind the figures, more in keeping with seventeenth-century principles of Baroque design.

Plate 28. *Christ preaching*. About 1643. Pen and bistre, 19·8 × 23 cm. Paris, Louvre (L. Bonnat Bequest). [Be. 543]
A study connected with the famous etching known as '*The Hundred Guilder Print*'.

Plate 29. *Female nude with a snake* (probably Cleopatra). About 1637. Red chalk, 24·5 × 14 cm. London, Villiers David. [Be. 137]
Rembrandt's un-idealizing, anti-classical approach to the nude was already being attacked in the seventeenth century. This study, obviously made from the life, almost certainly represents Cleopatra.

Plate 30. *Male nude*. About 1646. Pen and bistre, wash, heightened with white body-colour, over traces of red and black chalk, 25·2 × 19·3 cm. London, British Museum. [Be. 710]
This powerful drawing, which shows the same anti-classicizing tendencies as the '*Cleopatra*' (Plate 29), was made in connection with the etching of about 1646, usually known as *Studies from the Nude*.

Plate 31. *Scribe sharpening his quill by candlelight*. About 1635. Pen and wash in bistre, 12·5 × 12·3 cm. Weimar, Staatliche Kunstsammlungen. [Be. 263]

Plate 32. *Peasant boy and a little girl chasing a goose*. About 1633–4. Pen and bistre, 13·2 × 10·3 cm. Berlin, Kupferstichkabinett. [Be. 234]

Plate 33. *Man standing*. About 1639–40. Pen and bistre, 12·7 × 5·8 cm. London, Count Antoine Seilern. [Be. 184]

Plate 34. *Two Jews in discussion*. About 1641–2. Black chalk, 9·7 × 8·4 cm. Haarlem, Teyler Museum. [Be. 665]

Plate 35. *Seated man.* About 1650–1. Black chalk, 12·3 × 8·5 cm. Zürich, Kuffner
 Collection. [Be. 1076]
These five studies may serve to emphasize the vividness and economy of Rembrandt's
style and his acute powers of observation. So naturalistic are his effects, indeed,
that it is easy to overlook underlying layers of meaning and association. Plate 33,
for example, is a study (in reverse) for the man to the right of Christ who is
pointing to the invalid lying on the wheelbarrow in the *'Hundred Guilder Print'*;
and the gesture in the drawing was borrowed from the figure of St Matthew in
Leonardo's *Last Supper*, of which Rembrandt made several sketches – e.g. Plate
27, third figure from the right.

Plate 36. *Saul and his servants with the Witch of Endor.* About 1657. Pen and bistre,
 wash, in some places rubbed with the finger, 14·4 × 22·6 cm. The Hague,
 Bredius Museum. [Be. 1028]
An illustration to a passage in the First Book of Samuel (xxviii), which describes
how Saul, troubled by the forthcoming battle against the Philistines, disguises himself
and with two companions seeks out the Witch (or medium) of Endor, whom he
asks to summon up Samuel. The naturalism of the interpretation – it might almost
be a seventeenth-century inn scene – is an example of Rembrandt's unique ability
to give biblical scenes the 'tone' of everyday life without sacrificing their meaning
or their seriousness.

Plate 37. *An elephant.* Signed and dated 1637. Black chalk, 23·3 × 35·4 cm. Vienna,
 Albertina. [Be. 457]
The finest of four studies of elephants made about 1637, probably from life. An
elephant appears in the background of the *Adam and Eve* etching of 1638.

Plate 38. *A woman hanging on the gallows.* About 1654–6. Pen and bistre, wash, 17·6
 × 93 cm. New York, Metropolitan Museum of Art. [Be. 1105]
One of two studies of an executed criminal – the weapon of her crime, an axe,
hangs beside her on the gallows. Drawings like this and Plate 39 are a useful
corrective to the sentimental view of Rembrandt's art that was so widespread at
the end of the nineteenth century, and which still exerts a hold on the public.

Plate 39. *The beheading of prisoners.* About 1640. Pen and wash, 17·5 × 12·5 cm.
 Formerly Amsterdam, A.W.M. Mensing Collection. [Be. 478]
This drawing was probably made while Rembrandt was working out the design
of the 1640 etching, *The Beheading of John the Baptist.*

Plate 40. *Portrait of Cornelis Claesz. Anslo.* Signed and dated 1640. Red chalk, pen
 and wash in bistre, and Indian ink, heightened and corrected with white
 body-colour, 24·6 × 20·1 cm. Paris, Louvre (Edmond de Rothschild
 Bequest). [Be. 759]
Preparatory study for the large and elaborate painting of 1641 (Berlin), showing
Anslo (1592–1646), a Mennonite Minister, deep in conversation with a woman.
The mood of the picture suggests that he is offering her spiritual consolation. Rem-
brandt also etched a portrait of Anslo in 1641.

Plate 41. *Jacob's dream.* About 1644. Pen and wash in bistre, some corrections in
 white body-colour, 25 × 20·8 cm. Paris, Louvre. [Be. 557]
An interpretation of the passage in Genesis (xxviii) which describes how Jacob,
resting on his journey from Beer-sheba, dreamt 'that there was a ladder set up

on the earth, and the top of it reached to heaven; and behold, the angels of God were ascending and descending on it! And behold, the Lord stood above it and said, "I am the Lord, the God of Abraham your father and the God of Isaac; the land on which you lie I will give to you and to your descendants." '

Plate 42. *The Holy Family asleep, with angels.* About 1645. Pen and bistre, 17·5 × 21·3 cm. Cambridge, Fitzwilliam Museum (Louis C. G. Clarke Bequest). [Be. 569]

Similar in mood, and of approximately the same date as the exquisite painting of 1645, *The Holy Family with Angels* (Leningrad), this is among the most touching and, at the same time, in its imaginative freedom, one of the most daring of Rembrandt's Biblical studies.

Plate 43. *The star of the Kings.* About 1641–2. Signed. Pen and bistre, wash, 20·4 × 32·3 cm. London, British Museum. [Be. 736]

The scene illustrates the well-known and popular Dutch tradition of children carrying a star through the streets on the Feast of the Epiphany. The shading suggests that this is in fact a night scene, which is how Rembrandt treated it in a small etching of about 1654.

Plate 44. *The Holy Family.* About 1652. Reed-pen and bistre, wash, 22 × 19·1 cm. Vienna, Albertina. [Be. 888]

The frontal poses and the way the table is shown parallel to the picture surface testify to Rembrandt's increasingly classical approach to composition in the 1650s. Compared to *The Holy Family* of about 1645 (Plate 42), this drawing is heavier, the effect more deliberate and serious.

Plate 45. *St Peter's prayer before the raising of Tabitha.* About 1654–5. Reed-pen and wash, some corrections in white body-colour, 19 × 20 cm. Bayonne, Musée (Collection Bonnat). [Be. 949]

Another example (see also Plate 44) of Rembrandt's firmly constructed style of the 1650s. The scene illustrates a miracle described in *The Acts of the Apostles* (ix). St Peter was called to Joppa, where the corpse of Tabitha, a woman 'full of good works and acts of charity', lay in an upper room of her house. Peter 'knelt down and prayed; then turning to the body he said, "Tabitha, rise." And she opened her eyes, and when she saw Peter she sat up.'

Plate 46. *The mocking of Christ.* About 1656–7. Pen and bistre, 18·1 × 24·5 cm. United States, Private Collection. [Be. 1024]

An extraordinarily simple and direct interpretation of the moment preceding the Crucifixion when the soldiers put a crown of thorns on the head of Christ and mocked him. 'And they began to salute him, "Hail, King of the Jews!" And they struck his head with a reed and spat upon him, and they knelt down in homage to him' (Mark, xv).

Plate 47. *A thatched cottage.* About 1652. Reed-pen and bistre, in parts rubbed with the finger, 17·5 × 26·7 cm. Chatsworth, Trustees of the Chatsworth Settlement. [Be. 1282]

Among the most splendid of the famous series of landscape drawings at Chatsworth which were originally in the collection of Rembrandt's pupil, Flinck.

Plate 48. *A farmhouse among trees, beside a canal with a man in a rowing-boat.* About 1650. Pen and bistre, wash, some white body-colour, 13·3 × 20·4 cm. Chatsworth, Trustees of the Chatsworth Settlement. [Be. 1232]

Another of the Flinck drawings from the same group as Plate 47. The scene is on the Bullerwijck, near Amsterdam, with the spire of the Ouderkerk in the distance. Unlike the paintings of landscape, Rembrandt's drawings are conspicuously informal in character, and lack the dramatic chiaroscuro and fanciful detail that he put into the pictures. The drawings are close, in both their simplicity and their creation of atmosphere by subtle contrasts of tone, to the work of Jan van Goyen (1596–1656).

Plate 49. *Riverscape with a sailing-boat.* About 1654–5. Reed-pen, brush, wash and bistre, 10·9 × 21·3 cm. New York, Edwin A. Seasongood Collection. [Be. 1349]

The majority of Rembrandt's landscape drawings date from the 1640s and '50s. ·

Plate 50. *Boy resting against two pillows on a low chair, asleep.* About 1655–6. Pen and wash in bistre, 16·1 × 17·8 cm. London, British Museum. [Be. 1092]

Plate 51. *Boy in a wide-brimmed hat resting his chin on his right hand.* About 1655–6. Pen and bistre, wash, 8·5 × 9 cm. London, British Museum. [Be. 1093]

Plate 52. *Boy seated at a table.* About 1655–6. Pen and bistre, 9·7 × 8·4 cm. Stockholm, Nationalmuseum. [Be. 1094]

These three studies are evidently of the same model, who can almost certainly be identified with Titus, who was born in 1641 and died in 1668, the year of his marriage to Magdalena van Loo. His daughter, Titia, was born posthumously the following year. Compared to the studies of Saskia of twenty years earlier (Plates 14, 15, 17), the sketches of Titus are much more summary in technique.

Plate 53. *Nathan admonishing David.* About 1654–5. Reed-pen and bistre, wash, white body-colour, 18·3 × 25·2 cm. New York, Metropolitan Museum of Art. [Be. 948]

An illustration of the passage in *II Samuel* (xii) which describes how Nathan admonished King David for having killed Uriah, the Hittite, after seducing his wife, Bathsheba. The way in which the figures and, in particular, the robe of David, are shown in a relatively shallow space parallel to the picture plane is typical of the mid-1650s. The figure of Nathan is of the same patriarchal type as the *Blind Homer dictating to a Scribe* (1663, The Hague) and the dying Jacob in the 1656 canvas of *Jacob blessing the Children of Joseph* (Cassel). The exotic figure of David may owe something to the Indian miniatures that Rembrandt copied at this period.

Plate 54. *Lion resting.* About 1648–50. Pen and bistre, wash, touched with white body-colour, 9·7 × 17 cm. Paris, Louvre (Edmond de Rothschild Bequest). [Be. 781]

One of a series of lion studies made in the 1640s, presumably from the life. They were to prove useful for paintings such as 'The Concord of The State' (1641, Rotterdam), and in treating subjects such as St Jerome, one of whose attributes is a lion, and 'Daniel in the lions' den' (see Plate 55).

Plate 55. *Daniel in the lions' den.* About 1652. Reed-pen and bistre, with some white body-colour (partly oxidized), 22·2 × 18·5 cm. Amsterdam, Rijksprentenkabinet (C. Hofstede de Groot Bequest). [Be. 887]

The depiction of the lions was based on sketches from the life, such as Plate 54.

14

Plate 56. *Seated female nude.* About 1654–6. Pen and brush in bistre, 27·2 × 19·5 cm. Rotterdam, Museum Boymans-Van Beuningen. [Be. 1121]

One of a group of drawings of the female nude made in the mid-1650s at approximately the same time as Rembrandt was painting *Bathsheba with David's Letter* (1654, Louvre). The realistic attitude to the female body remains the same as it was in the early 1630s (see Plate 2), but the style has of course changed. The handling here is freer and richer and the treatment both simpler and grander.

Plate 57. *A girl sleeping.* About 1655–6. Brush and bistre, wash, 24·5 × 20·3 cm. London, British Museum. [Be. 1103]

To be counted among Rembrandt's finest and most celebrated drawings, this study of a sleeping girl shows an economy, a breadth and a mastery of handling that he was never to surpass. The model was almost certainly Hendrickje Stoffels (1625/6(?)–1663), who is first documented in his household in October, 1649. Although she bore him a daughter, Cornelia (baptized on 30 October 1654), and in spite of being officially admonished by the Church Council for living in sin, Hendrickje never married Rembrandt, who would have been obliged, on re-marriage, to give up half of Saskia's estate (see note to Plate 14). There is no documented likeness of Hendrickje, as there is of Saskia (see Plate 10), but there can be little doubt that she is the subject of several portraits (such as the Berlin *Woman at a Window* and the ex-Morrison canvas recently acquired by the National Gallery, London) and subject pictures like the *Woman Bathing in a Stream* (1654, National Gallery, London) and the Louvre *Bathsheba*, also of 1654.

Plate 58. *Christ healing a sick woman.* About 1659–60. Pen and bistre, wash, white body-colour, 17·2 × 18·8 cm. Paris, Fondation Custodia (Collection F. Lugt). [Be. 1041]

A superb example of Rembrandt's mature style as a draughtsman: vivid, compact and monumental, and with the movement of the figures perfectly observed. The subject comes from Matthew (xiv): 'And when Jesus entered Peter's house, he saw his mother-in-law lying sick with a fever; he touched her hand, and the fever left her, and she rose and served him.'

Plate 59. *Cottages beneath high trees.* About 1657–8. Pen and brush in bistre, wash, 19·5 × 31 cm. Berlin, Kupferstichkabinett. [Be. 1367]

One of Rembrandt's late landscape drawings. In comparison with Plate 47, the style is now freer and the pen work more rugged. A parallel development can be observed in the paintings.

Plate 60. *Young woman seated in an armchair.* About 1655–6. Reed-pen and wash in blackish brown bistre, 16·5 × 14·4 cm. London, British Museum. [Be. 1174]

This important study turned up in a London auction sale in 1948, when it was bought by the British Museum. The sitter, who is the same model as in the *Girl sleeping* (Plate 57), must be Hendrickje Stoffels (see note to Plate 57); and the drawing may have been a study for a painting. The three-quarter length seated portrait is familiar in the pictures of the 1650s. The damaged Louvre portrait of Hendrickje, which has evidently been cut down, also offers a point of comparison. The costume worn in the drawing does not accord with the usual dress of the period and may have been one of the props that Rembrandt is known to have kept about the studio.

Plate 61. *Portrait of a man.* About 1662–5. Reed-pen and bistre, white body-colour, 24·7 × 19·2 cm. Paris, Louvre. [Be. 1182]

A very free, late portrait-study, from the same period as the group portrait of 1662 known as *De Staalmeesters* (Rijksmuseum, Amsterdam). The man wears the fashionable middle-class costume of the day.

Plate 62. *Self-portrait.* About 1627–8. Pen and bistre, brush and Indian ink, 12·7 × 9·5 cm. London, British Museum. [Be. 53]

Plate 63. *Self-portrait.* About 1628–9. Pen and bistre, brush and Indian ink, 12·7 × 9·5 cm. Amsterdam, Rijksprentenkabinet. [Be. 54]

Plate 64. *Self-portrait.* About 1634. Pen and bistre, wash, 12·3 × 13·7 cm. Berlin, Kupferstichkabinett. [Be. 432]

Plate 65. *Self-portrait.* About 1636–8. Pen and wash, in bistre and Indian ink, 14·5 × 12·1 cm. New York, Metropolitan Museum of Art (Robert Lehman Collection). [Be. 434]

Plate 66. *Self-portrait.* About 1657–8. Pen and bistre, 6·9 × 6·2 cm. Rotterdam, Museum Boymans-Van Beuningen. [Be. 1176]

Plate 67. *Self-portrait.* About 1660. Pen and bistre, 8·4 × 7·1 cm. Vienna, Albertina. [Be. 1177]

Plate 68. *Self-portrait.* About 1655–6. Pen and bistre, 20·3 × 13·4 cm. Amsterdam, Rembrandt-Huis. [Be. 1171]

Rembrandt's self-portraits constitute one of the great autobiographies in European art. They reflect not only his changing appearance, recorded with unsparing frankness, but also his style as it developed and matured. Whether painted, drawn or etched, the self-portraits have fundamental traits in common. Plate 62, a work of the late 1620s, is close in spirit to the etching and the Munich painting, both of 1629, and to the etchings of 1630, which, like it, are studies in expression. Plate 65, which probably dates from the second half of the 1630s, is close in character to a panel now in the Norton Simon Collection. Plate 66 should be compared with the head-and-shoulders portrait in Vienna, while Plate 67 belongs to the same emotional world as the small etching of 1658 and the three-quarter length canvases in the Louvre and at Kenwood, London, respectively.

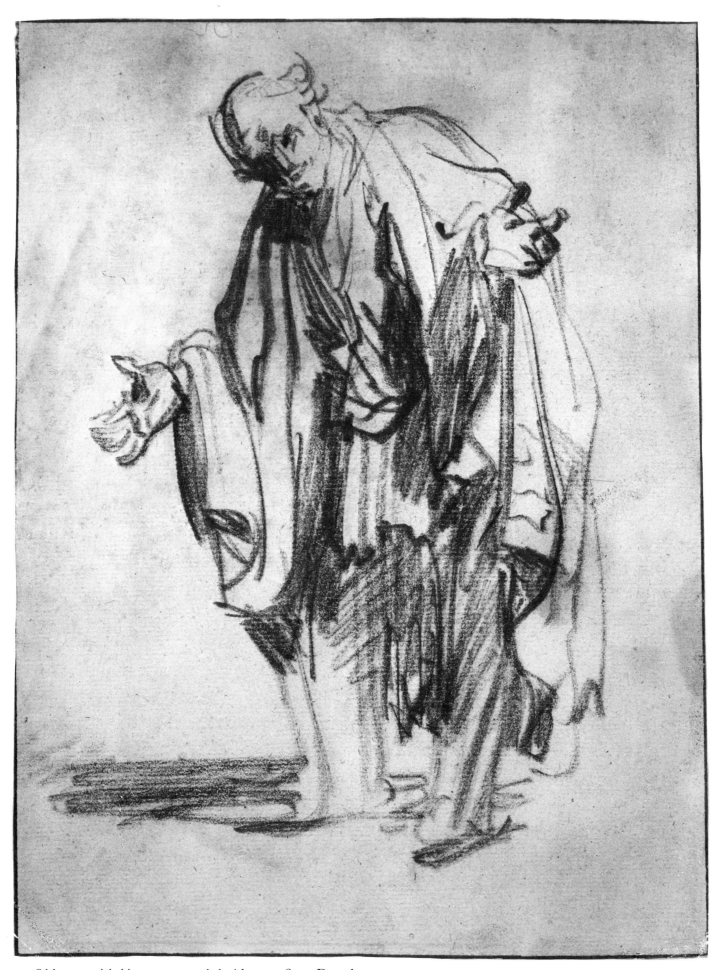

1. *Old man with his arms extended.* About 1629. Dresden

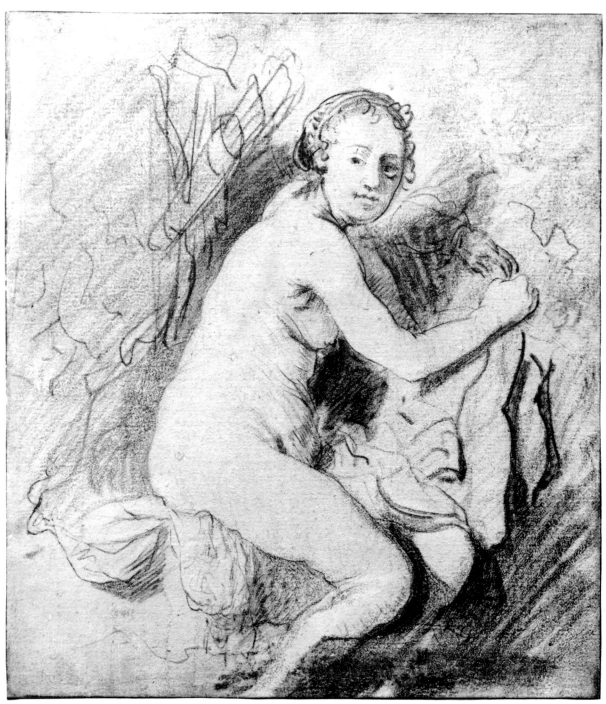

2. *Diana at the bath.* About 1630–1. London

Already, in the seventeenth century, Rembrandt's realistic approach to the nude, evident in this powerful study for an etching of *Diana at the bath*, was attacked by conservative critics. This love of realism was often combined with a deep affection for old age, as the drawing on the right shows.

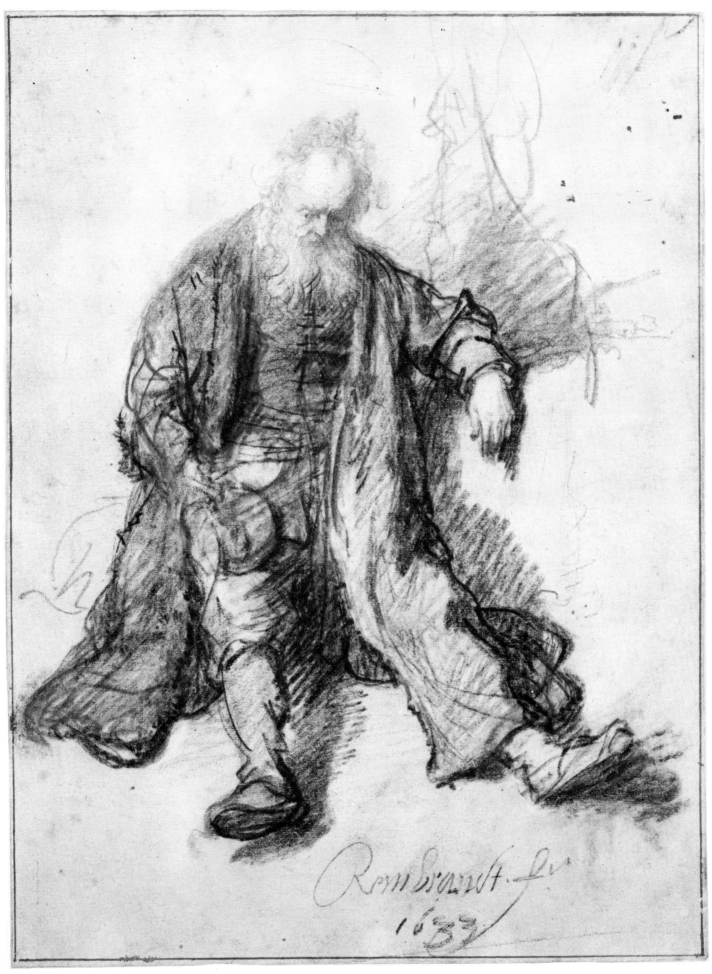

3. *Study for Lot drunk*. 1633. Frankfurt

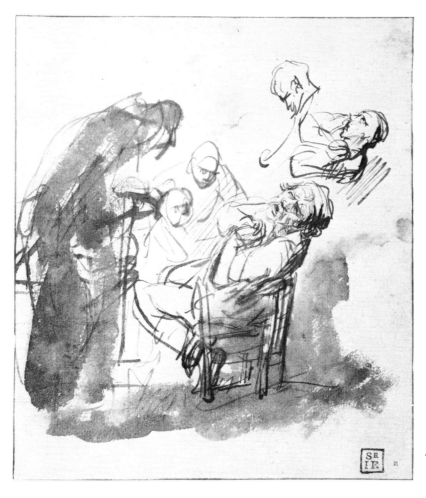

4. *Study for Jacob lamenting.*
About 1635. Berlin.

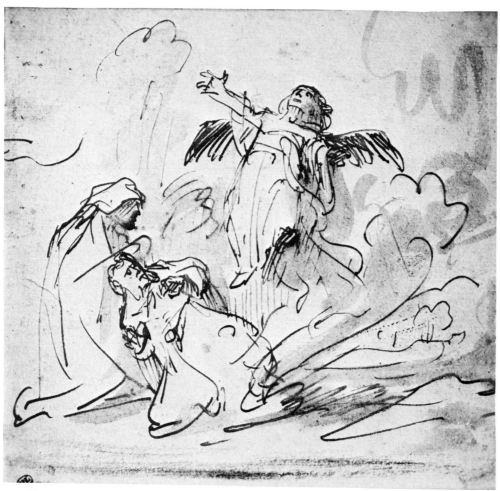

5. *The angel departs from Manoah and his wife.* About 1639. Paris

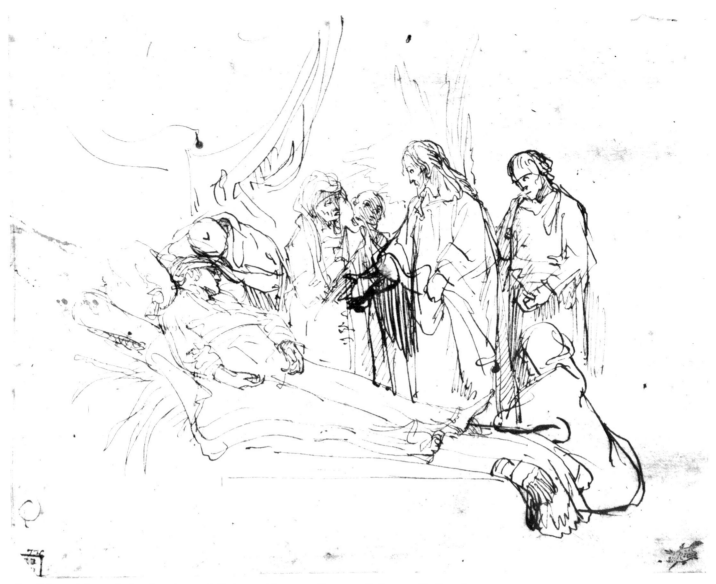

6. *The raising of the daughter of Jairus.* About 1632–3. Private Collection

No other artist, before or since, has equalled Rembrandt's ability to see the episodes of the Bible in almost contemporary terms. Rembrandt seems to strip away centuries of visual tradition in his attempt to communicate the vitality and psychological power of the Old and New Testaments.

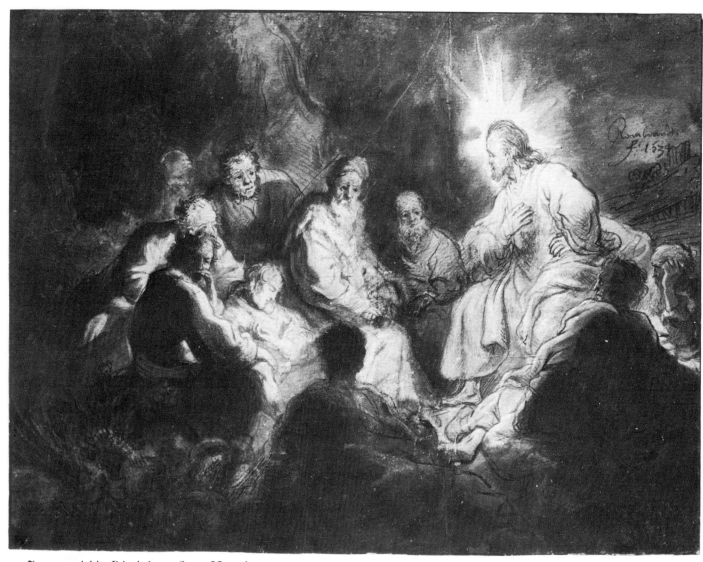

7. *Jesus and his Disciples*. 1634. Haarlem

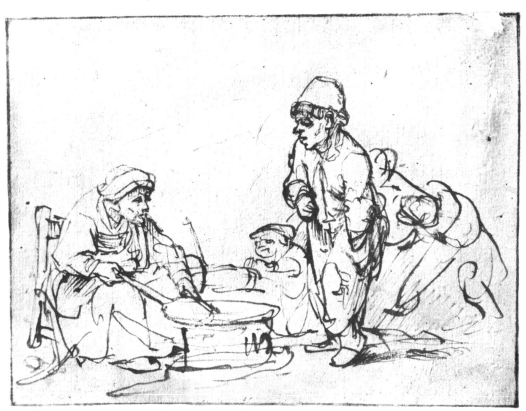

8. *The pancake woman*. About 1635. Amsterdam

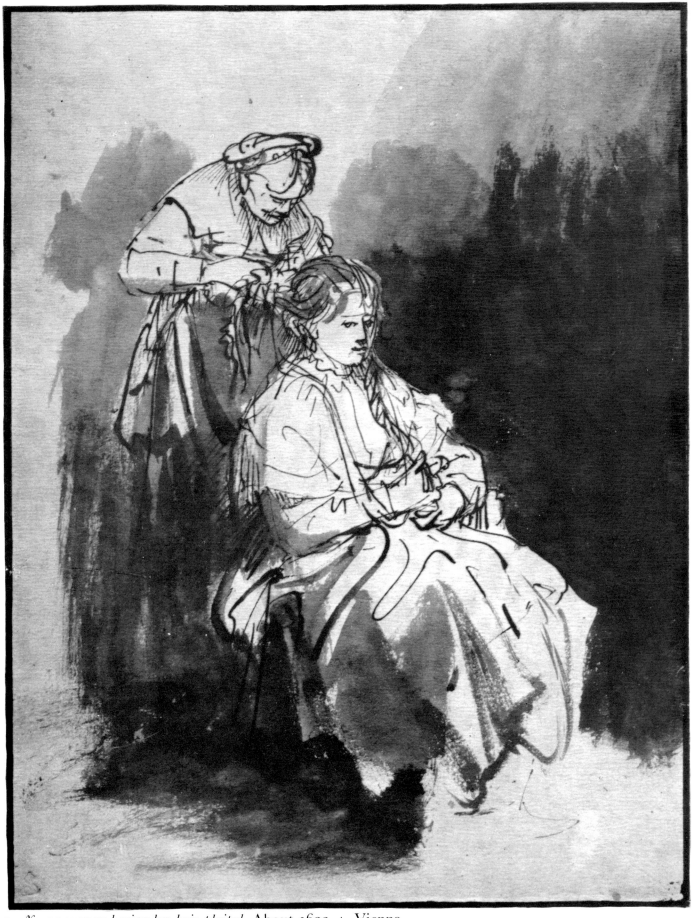

9. *Young woman having her hair plaited.* About 1632–4. Vienna

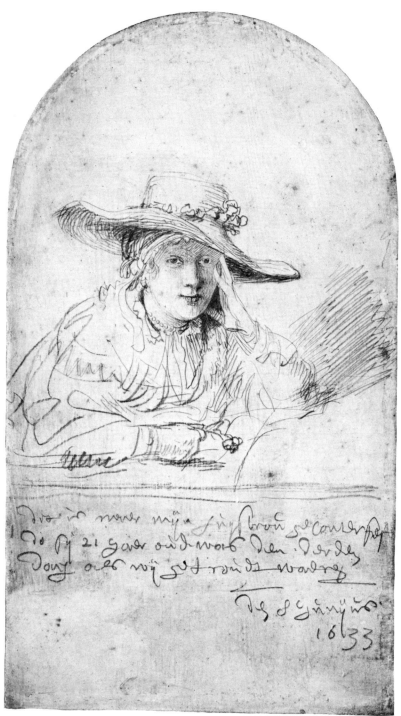

10. *Portrait of Saskia in a straw hat.* 1633. Berlin

This charming study of Rembrandt's wife, Saskia, was
made at the time of their engagement. The inscription
is in Rembrandt's own hand and reads: 'This is drawn
after my wife, when she was 21 years old, the third day
after our betrothal – the 8th of June 1633.' The fine portrait
on the right is elaborately drawn and would have been
regarded as a finished work of art. It is the only surviving
example of this type of work among Rembrandt's drawings.

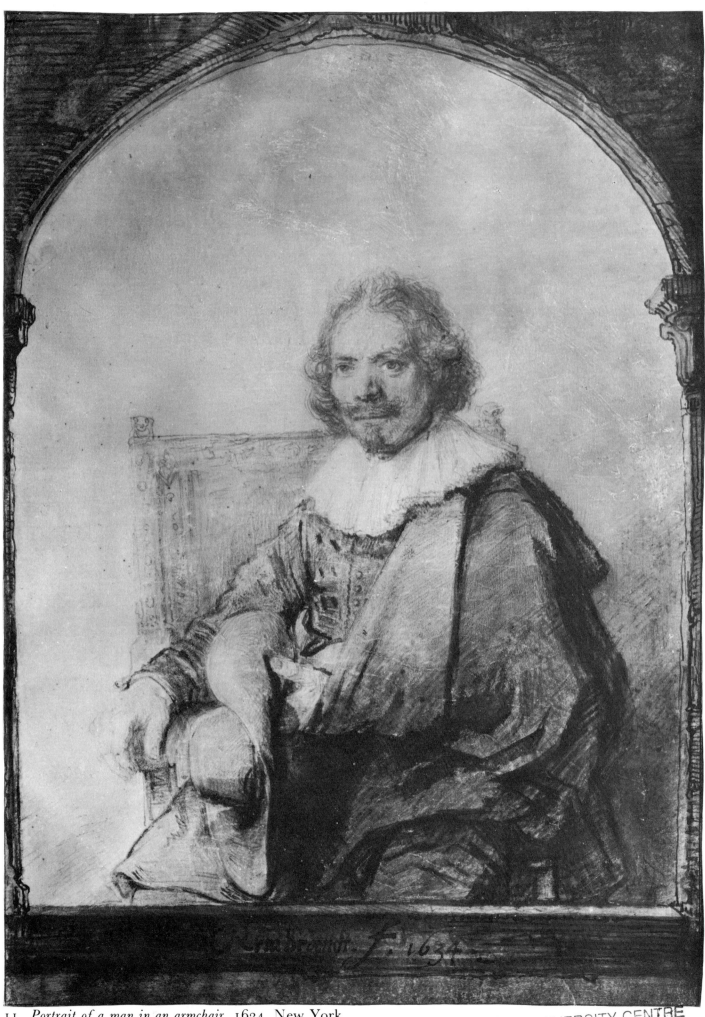

11. *Portrait of a man in an armchair.* 1634. New York

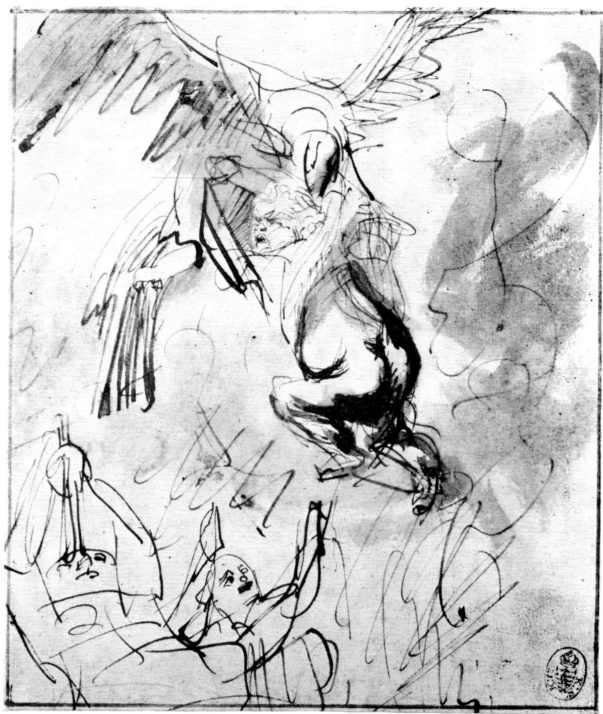

12. *The abduction of Ganymede*. 1635. Dresden

Plates 12 and 13 demonstrate, rather clearly, the way in which Rembrandt's treatment of biblical and mythological stories was influenced by his observation of everyday life. Plate 13 is a wonderfully vivid sketch of a small boy being hauled off by his mother. Plate 12, on the other hand, shows Ganymede, equally distressed, being abducted by Zeus, disguised as an eagle. It is obvious that the interpretation was based on what Rembrandt saw going on in his own neighbourhood.

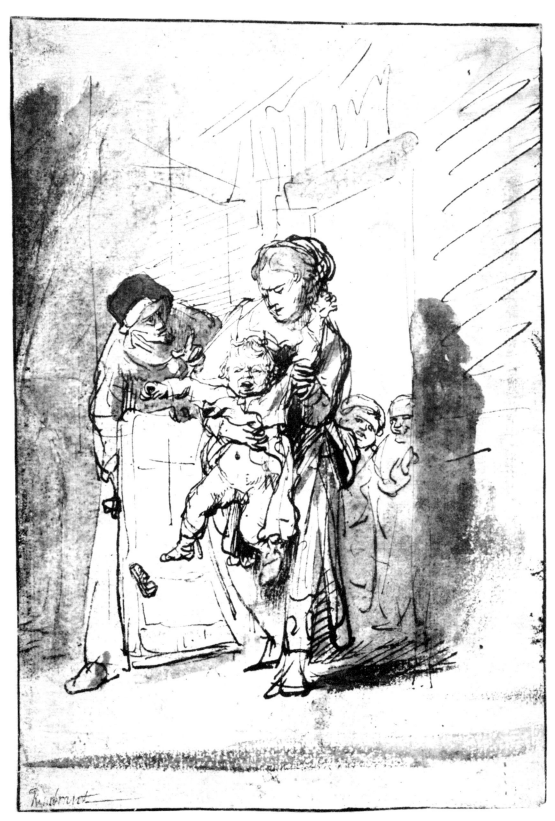

13. '*The naughty boy*'. About 1635. Berlin

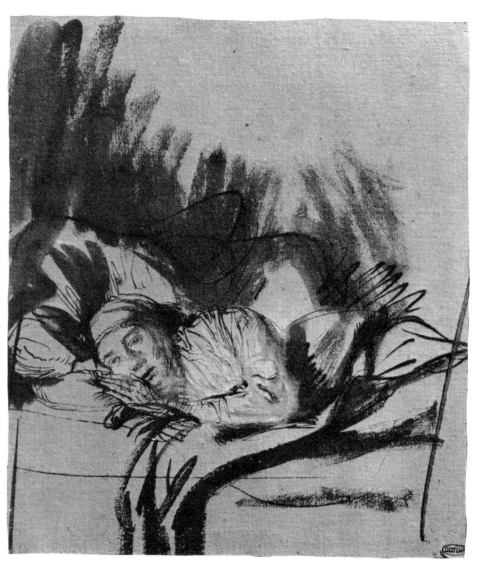

14. *Sick woman lying in bed (probably Saskia)*. About 1635. Paris

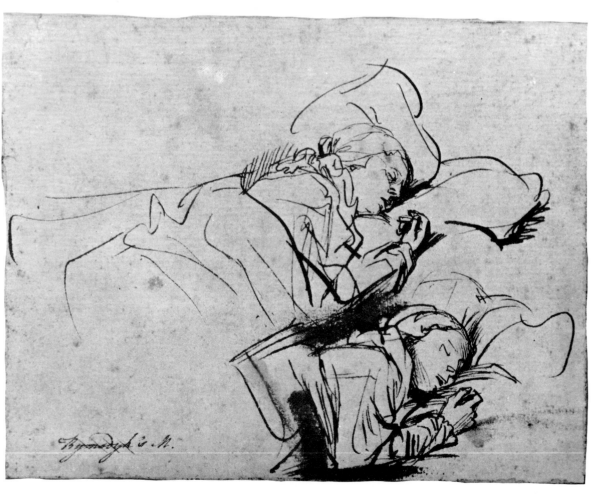

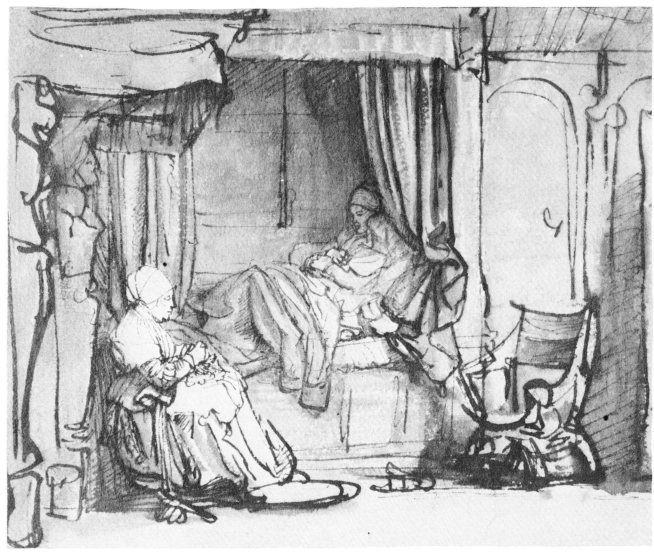

16. *Saskia's lying-in room.* About 1639. Paris

17. *Saskia asleep in bed.* About 1635.
Brussels

These four superb and very intimate
drawings show Saskia in bed. Plate 14
probably shows her during an illness. Plate
16 may well depict her during one of her
four pregnancies.

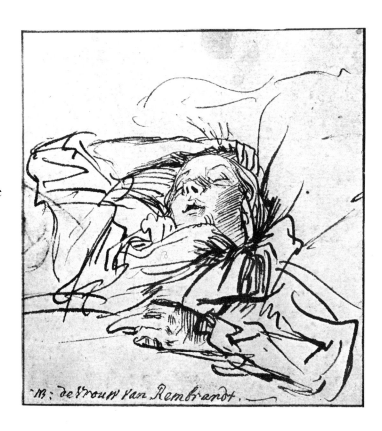

Opposite : 15. *Two studies of Saskia asleep in
bed.* About 1635. New York

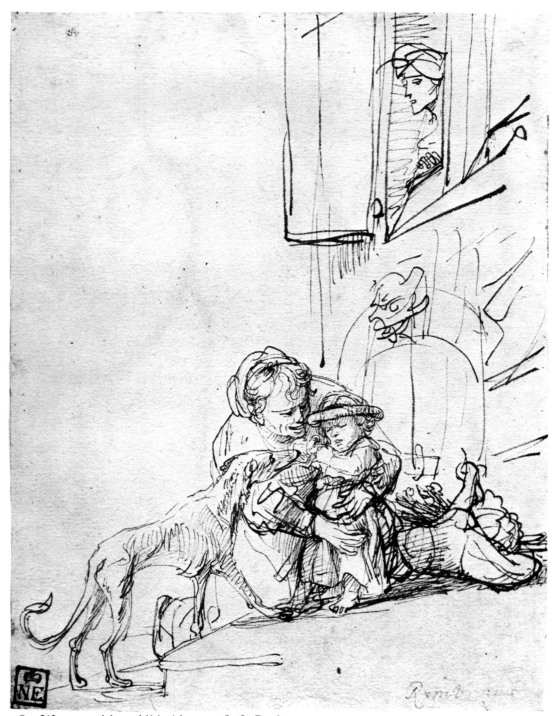

18. *Woman with a child*. About 1636. Budapest

Rembrandt always had a wonderful sympathy towards children, and the study
of the *Virgin and Child* (Plate 19) combines acute observation and great tenderness.

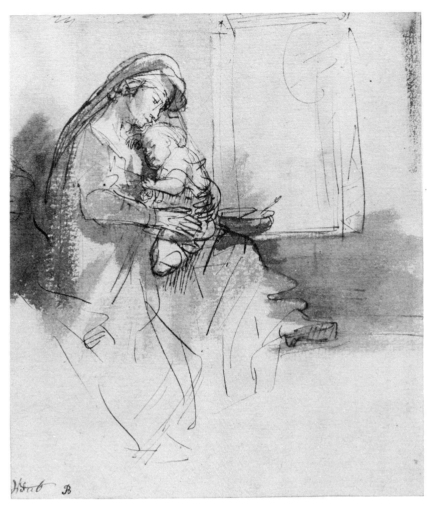

19. *The Virgin and Child seated near a window.* About 1635. London

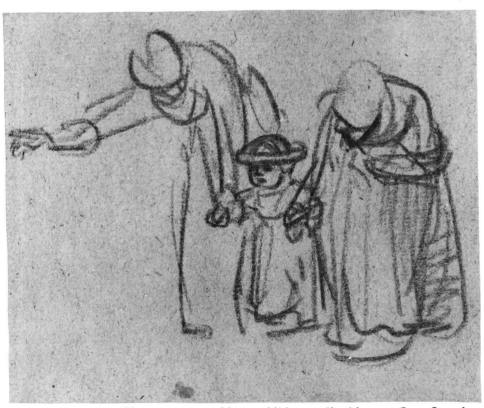

20. *Two women teaching a child to walk.* About 1637. London

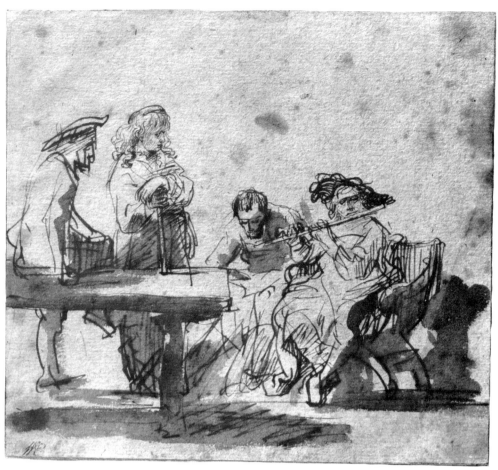

21. *Group of musicians listening to a flute-player.* About 1635. Private Collection

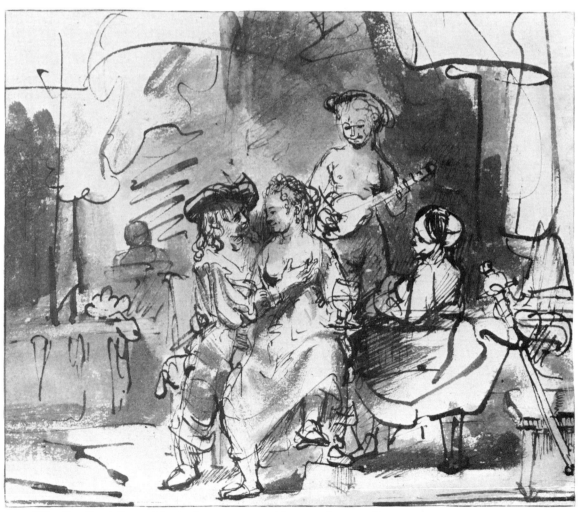

22. *The Prodigal Son with the loose women.* About 1642–3. Basle

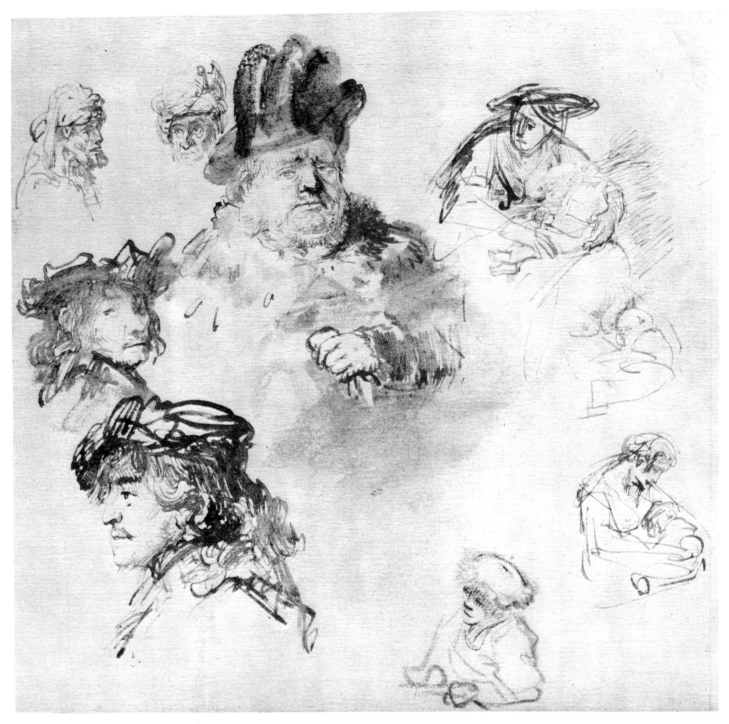

23. *Sheet of studies*. About 1636. Birmingham

Plate 23 neatly illustrates, in one drawing, several of Rembrandt's major preoccupations as an artist.
There is the fascination with richness and display, evident in the fanciful headgear of the men;
the swift drawing of a mother and child is rather characteristic of Rembrandt's concern with all
aspects of ordinary life; while the faces reveal his keen eye for physiognomy.

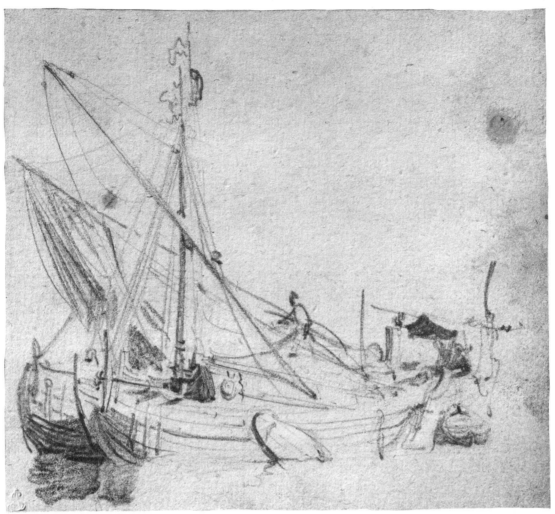

24. *Two sailing-boats at anchor.* About 1636. Vienna

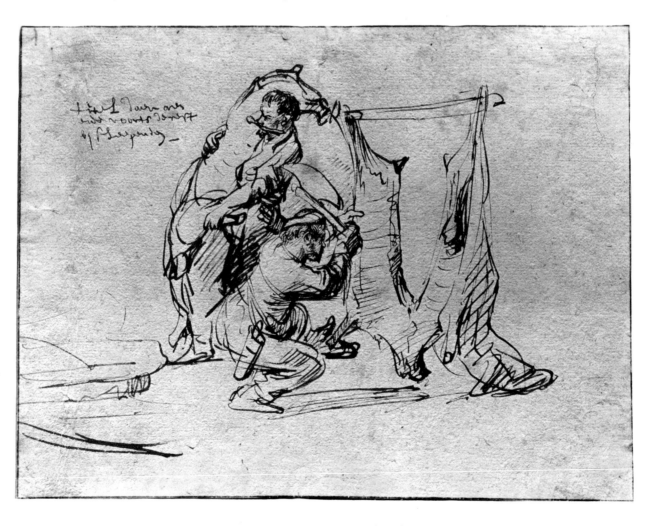

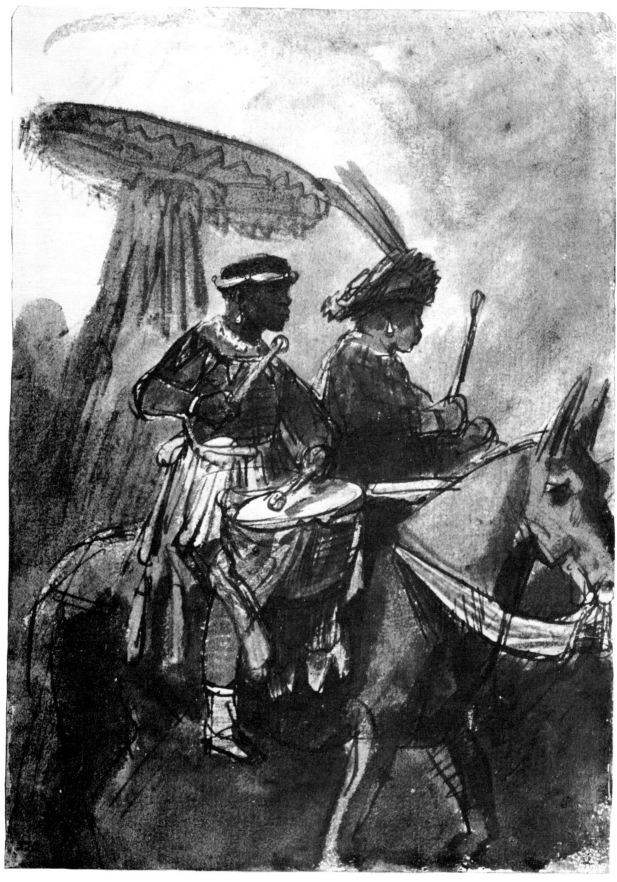

26. *Two negro drummers mounted on mules.* About 1637–8. London

Opposite: 25. *Two butchers at work.* About 1635. New York

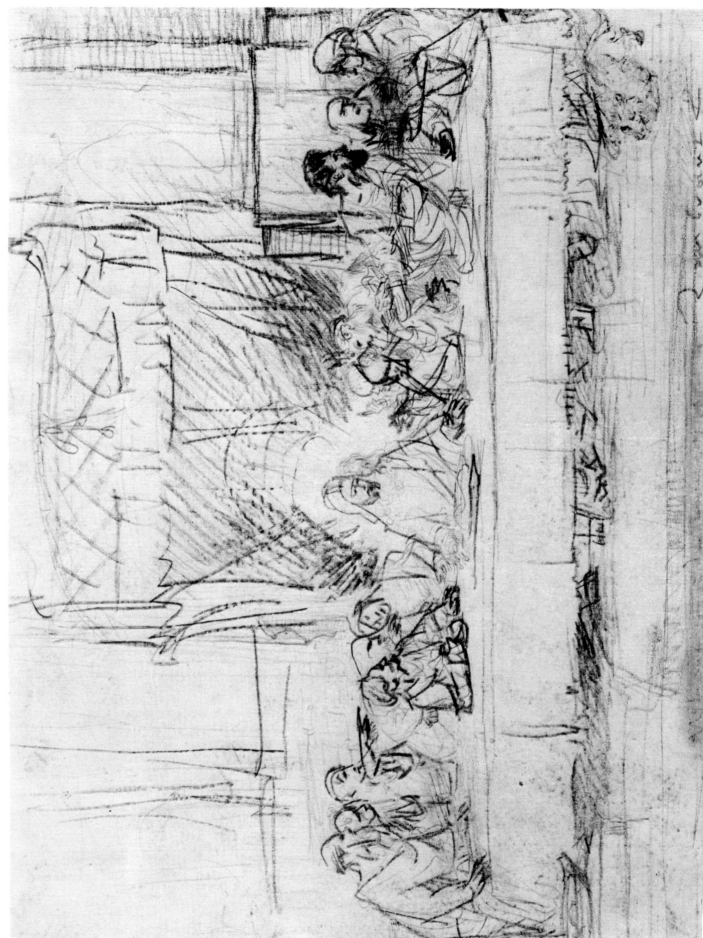

27. *The Last Supper* (after Leonardo da Vinci). About 1635. New York

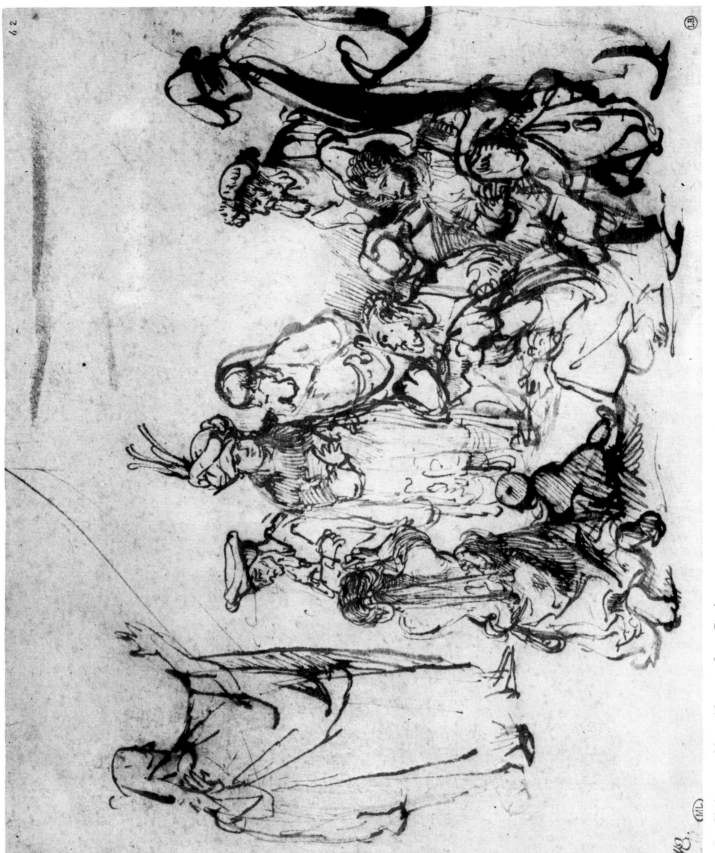

28. *Christ preaching.* About 1643. Paris

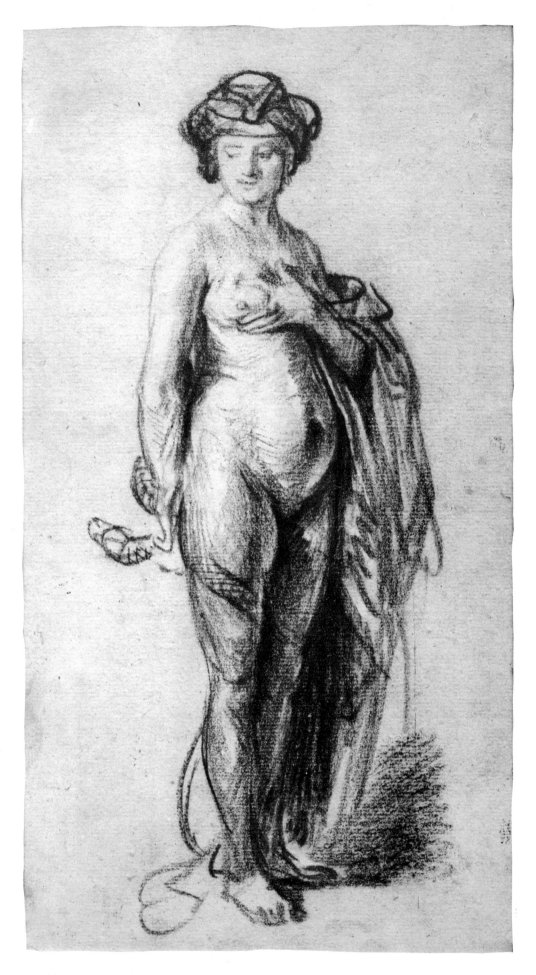

29. *Female nude with a snake*. About 1637. Private Collection

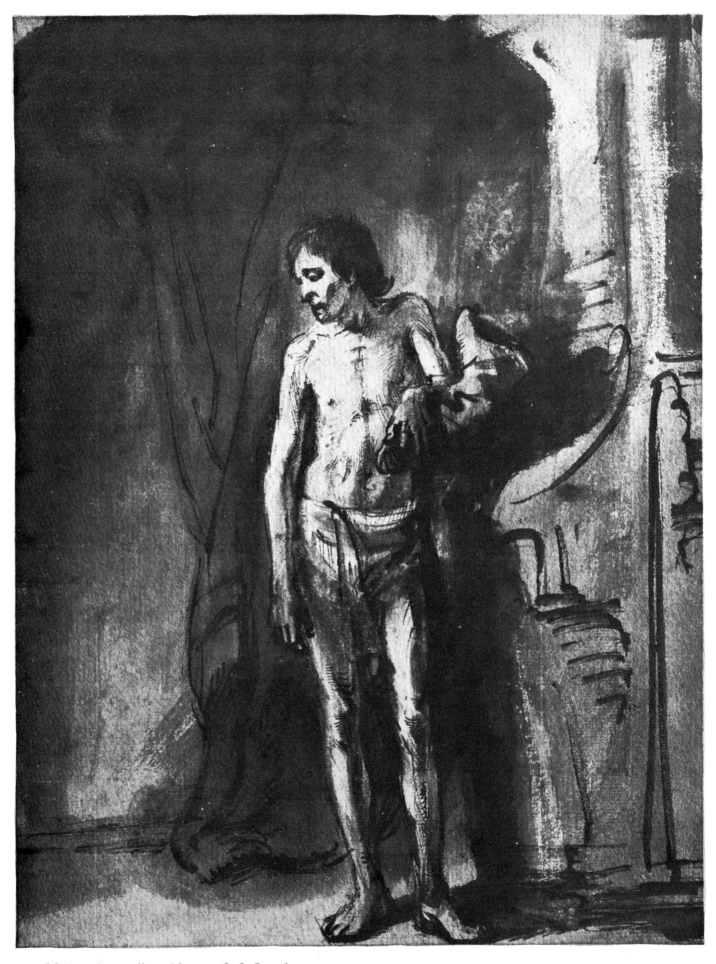

30. *Male nude standing*. About 1646. London

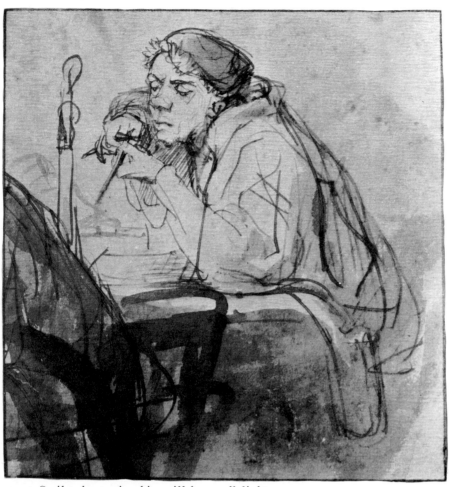

31. *Scribe sharpening his quill by candlelight.*
About 1635. Weimar

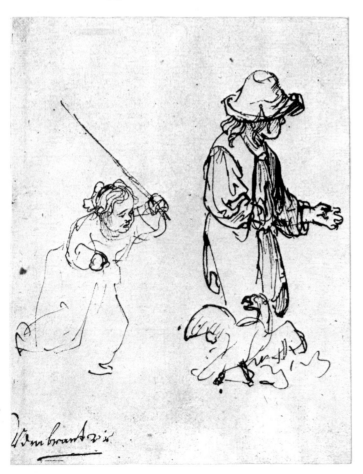

32. *Peasant boy and a little girl chasing a goose.* About
1633–4. Berlin

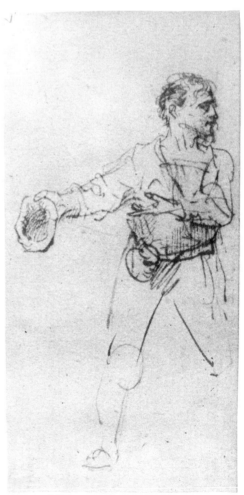

33. *Man standing.* About 1639–40.
London

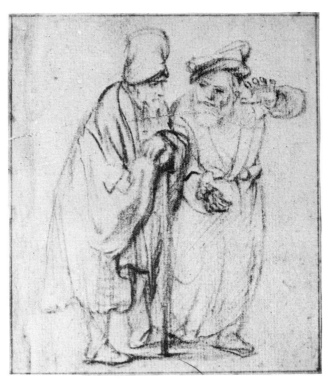

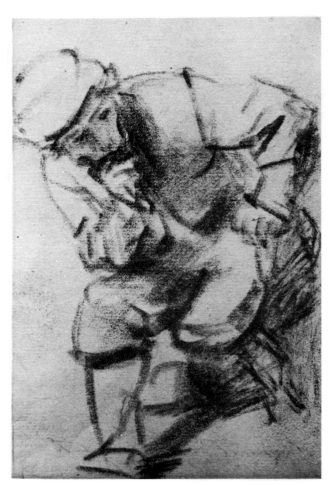

34. *Two Jews in discussion*. About 1641–2. Haarlem

35. *Seated man*. About 1650–1. Zürich

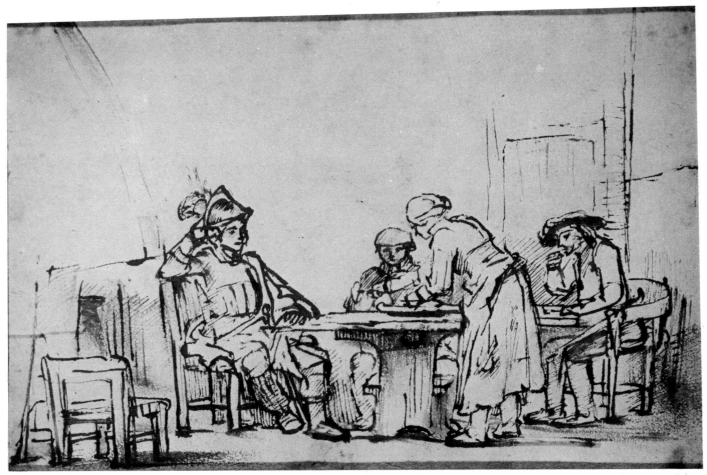

36. *Saul and his servants with the Witch of Endor*. About 1657. The Hague

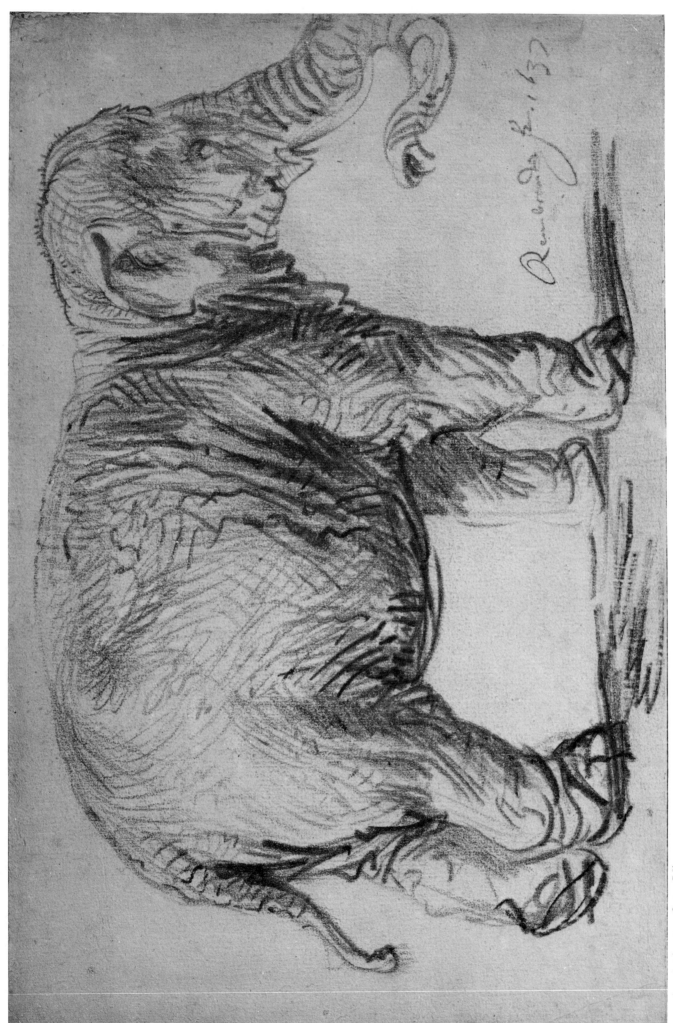

37. *An elephant.* 1637. Vienna

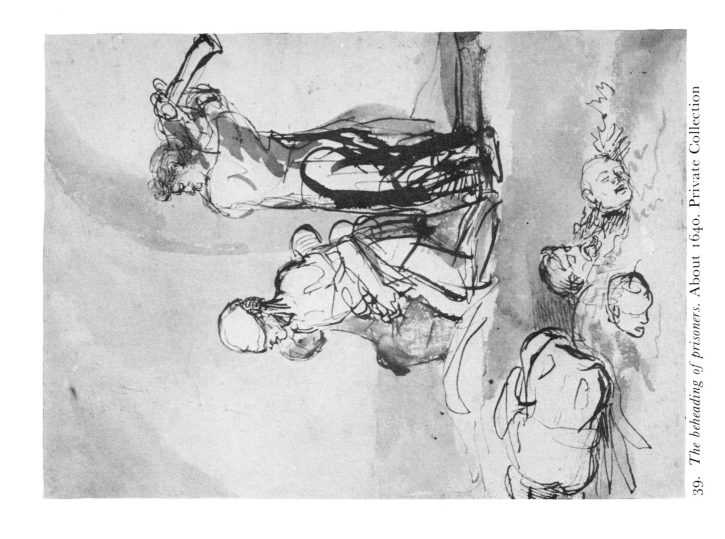

39. *The beheading of prisoners. About 1640. Private Collection*

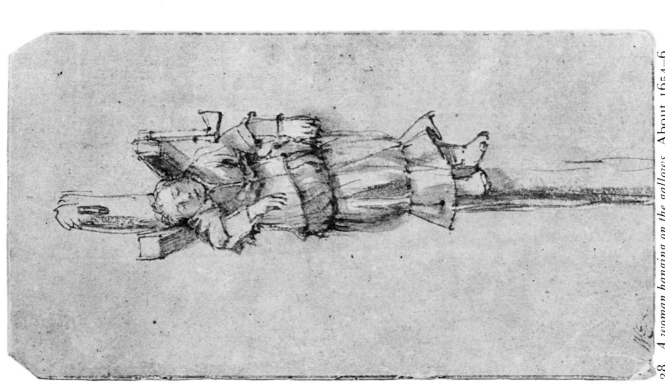

38. *A woman hanging on the gallows. About 1654–6. New York*

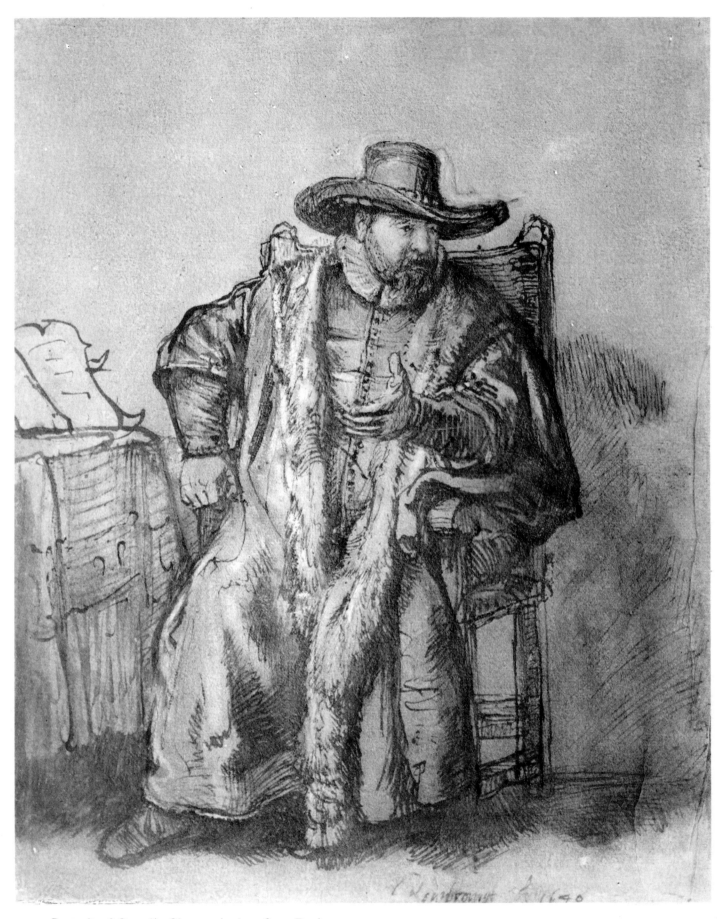

40. *Portrait of Cornelis Claesz. Anslo.* 1640. Paris

An elaborate study for a large oil painting which shows the famous Mennonite preacher offering words of consolation to a widow.

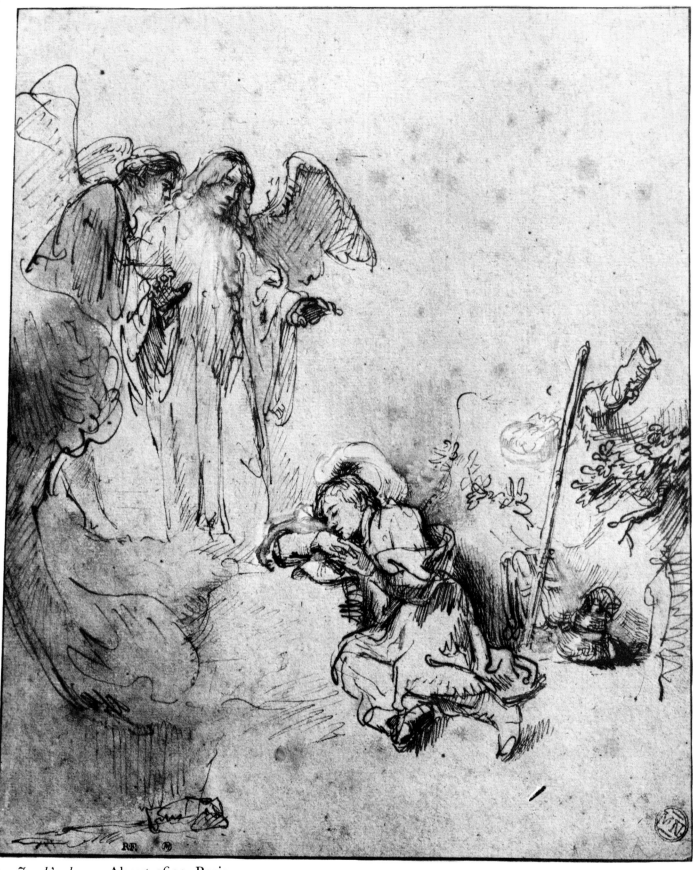

41. *Jacob's dream*. About 1644. Paris

One of the most interesting features of this beautiful drawing is the way in which the heavenly
angel is seen in purely human terms.

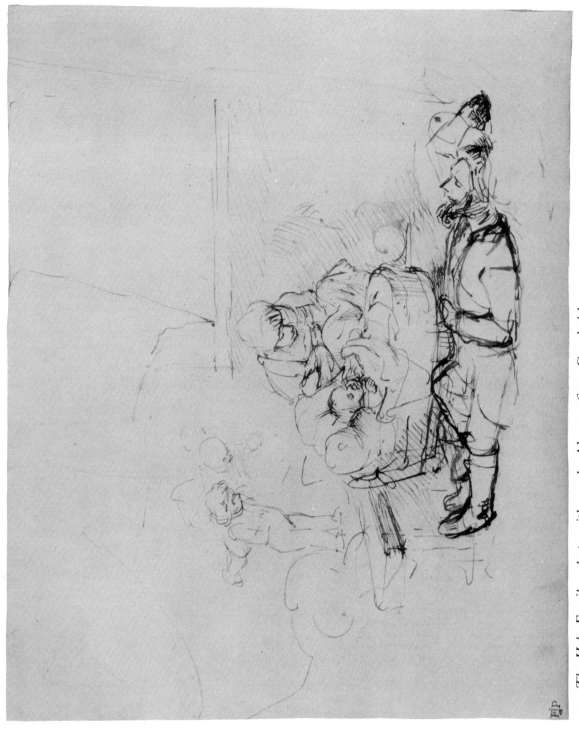

42. *The Holy Family asleep, with angels. About 1645. Cambridge*

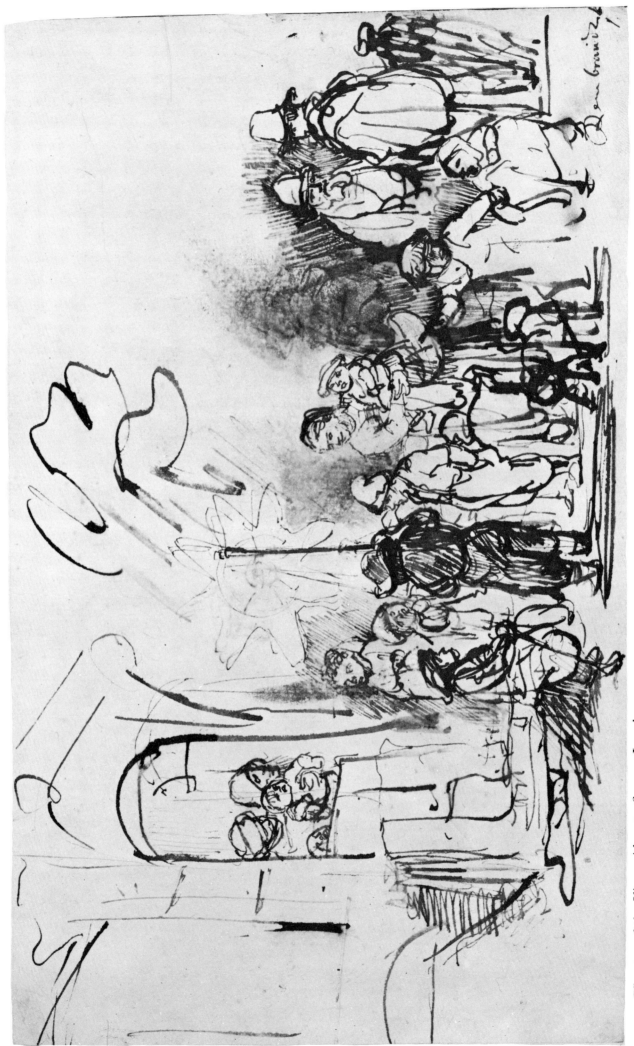

43. *The star of the Kings. About* 1641–2. London

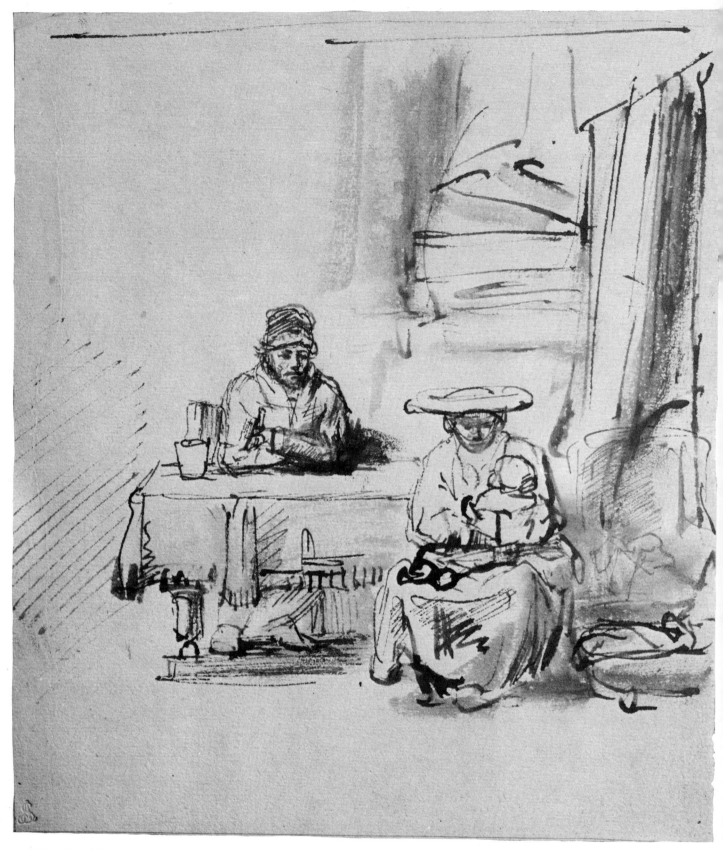

44. *The Holy Family*. About 1652. Vienna

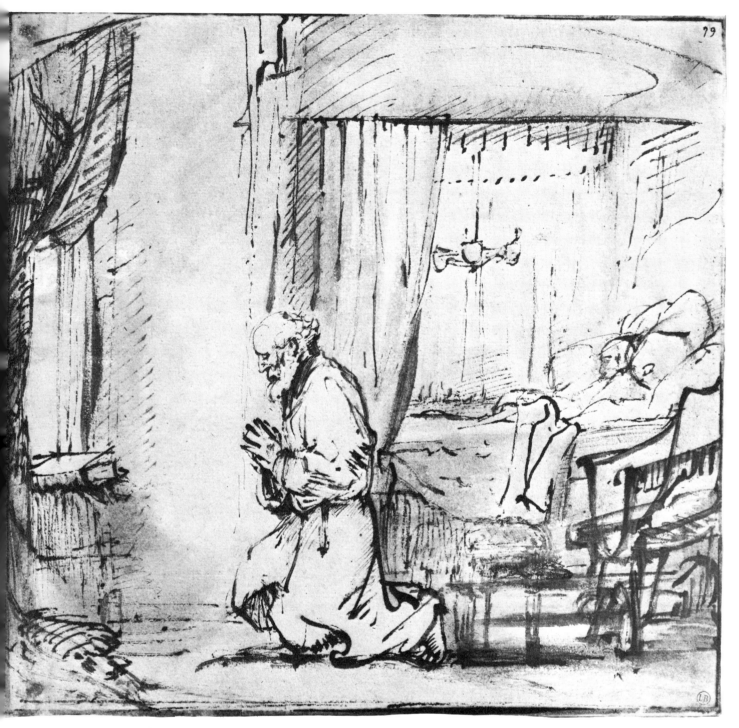

45. *St Peter's prayer before the raising of Tabitha.* About 1654–5. Bayonne

This superb drawing illustrates a miracle described in the Acts of the Apostles: St Peter was called to Joppa, where the corpse of Tabitha, a woman 'full of good works and acts of charity', lay in an upper room of her house. Peter knelt down and prayed; then turning to the bed he said, 'Tabitha, rise,' and she opened her eyes, and when she saw Peter she sat up.

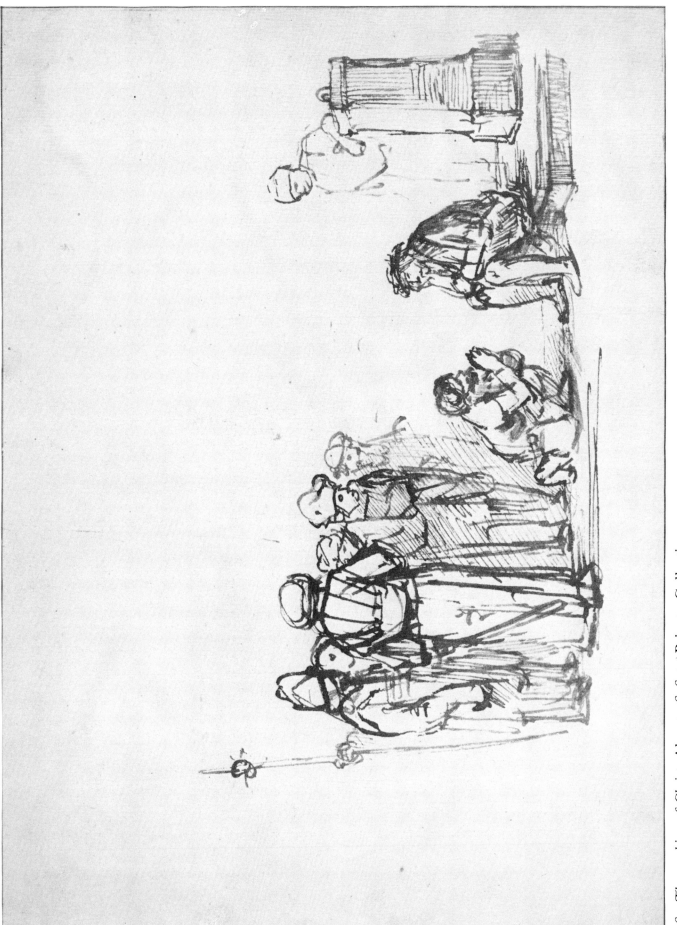

46. *The mocking of Christ.* About 1656–7. Private Collection

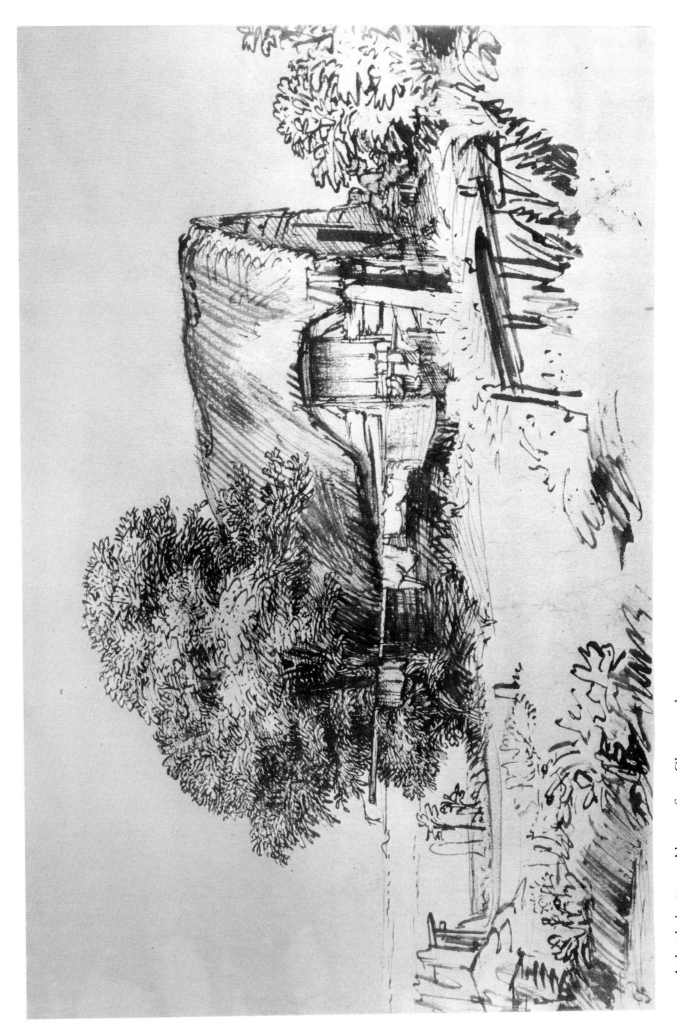

47. *A thatched cottage.* About 1652. Chatsworth

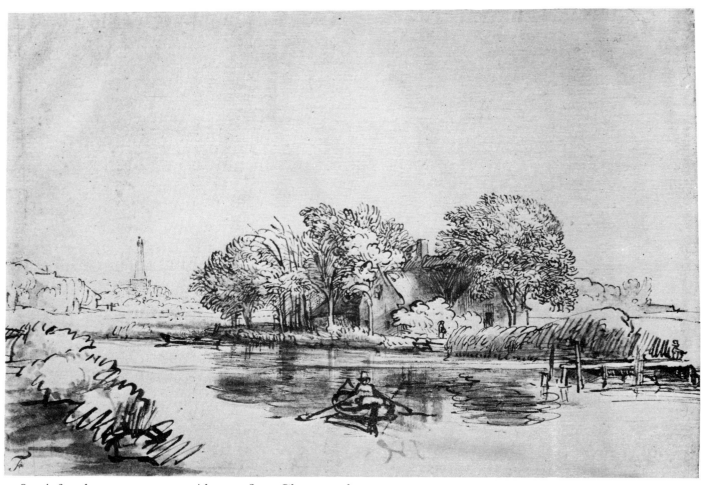

48. *A farmhouse among trees.* About 1650. Chatsworth

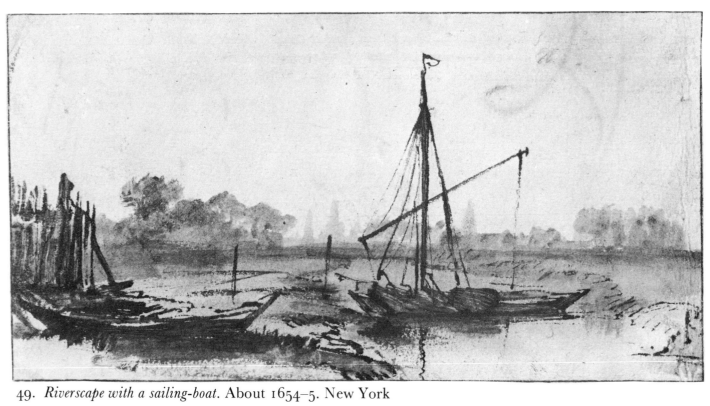

49. *Riverscape with a sailing-boat.* About 1654–5. New York

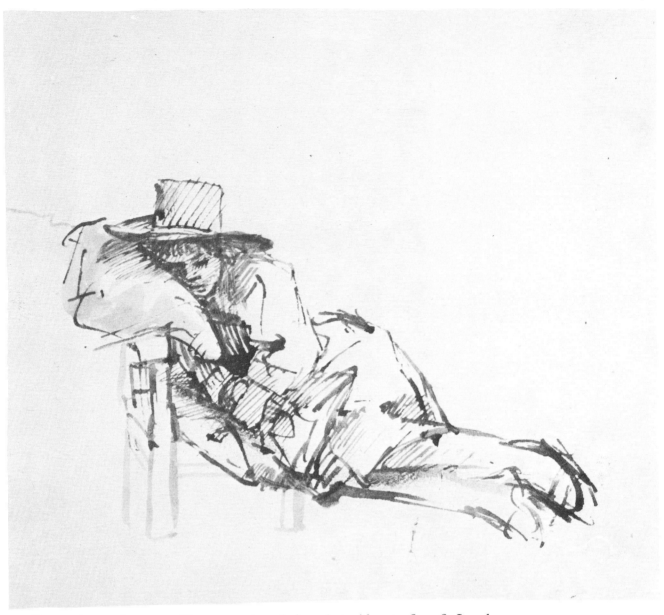

50. *Boy resting against two pillows on a low chair, asleep.* About 1655–6. London

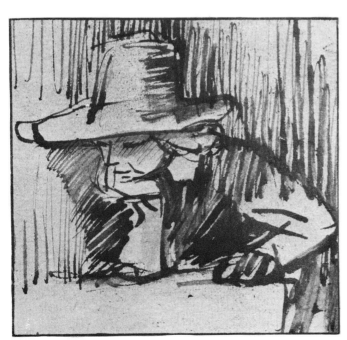

51. *Boy in a wide-brimmed hat.* About 1655–6.
London

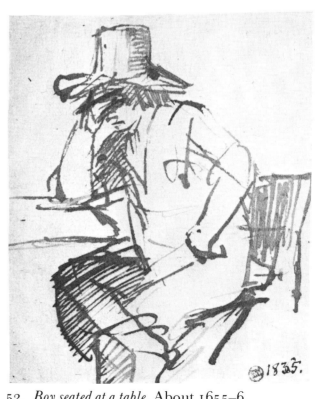

52. *Boy seated at a table.* About 1655–6.
Stockholm

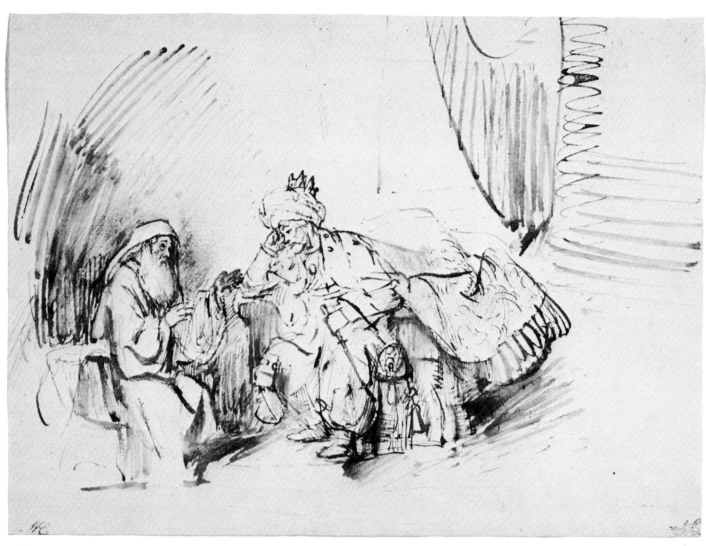

53. *Nathan admonishing David*. About 1654–5. New York

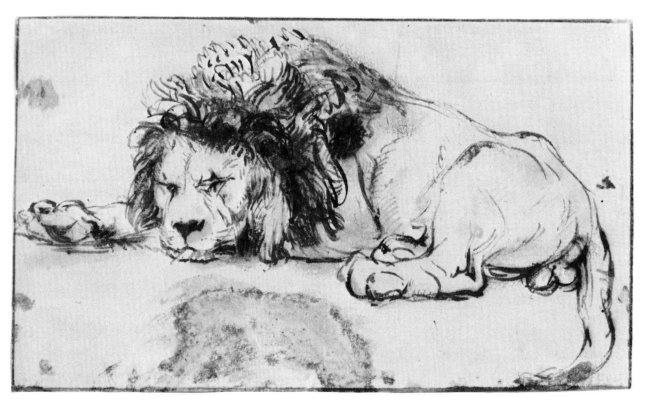

54. *Lion resting*. About 1648–50. Paris

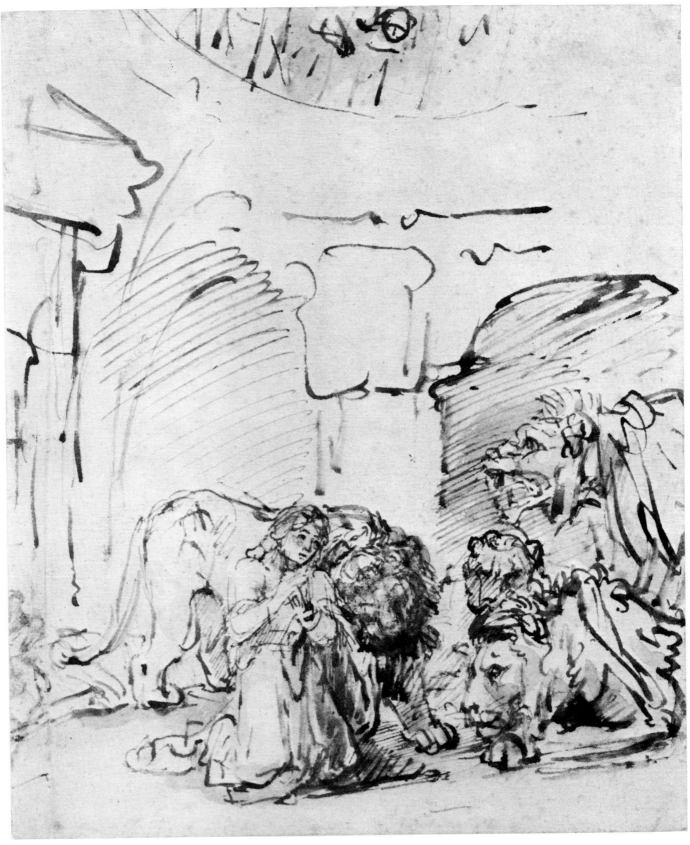

55. *Daniel in the lions' den*. About 1652. Amsterdam

It is quite possible that the idea of illustrating the story of *Daniel in the lions' den* (above) came to
Rembrandt after he had made a series of drawings of lions, which he must have seen in Amsterdam.

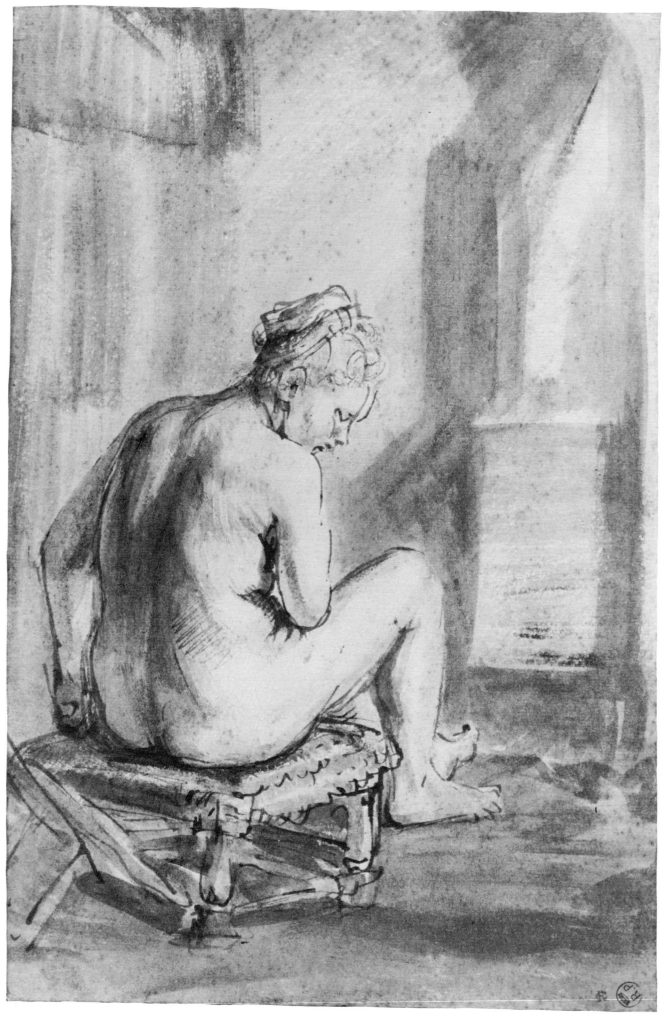

56. *Seated female nude.* About 1654–6. Rotterdam

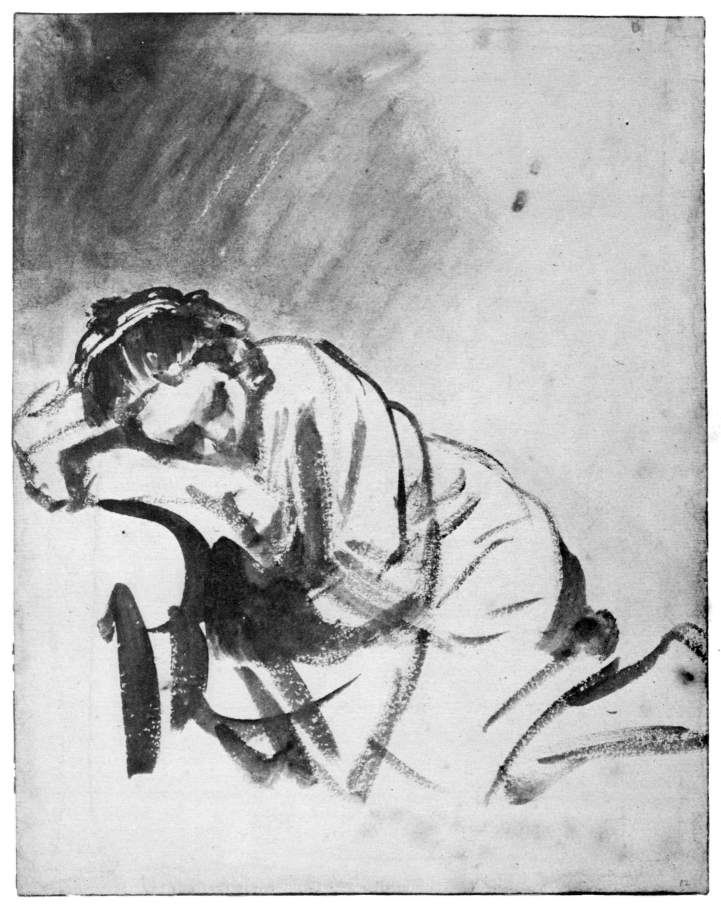

57. *A girl sleeping*. About 1655–6. London

This famous and beautiful drawing represents Rembrandt's mistress, Hendrickje, asleep.

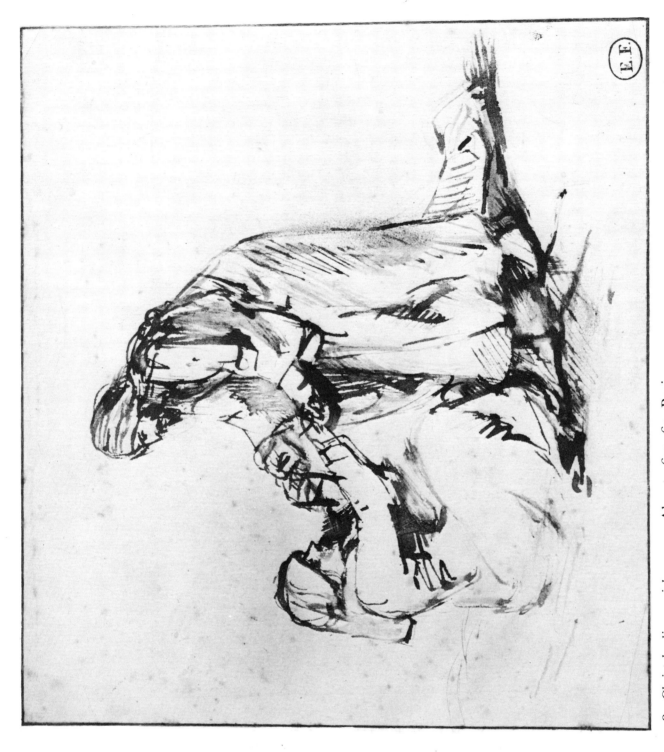

58. *Christ healing a sick woman.* About 1659–60. Paris

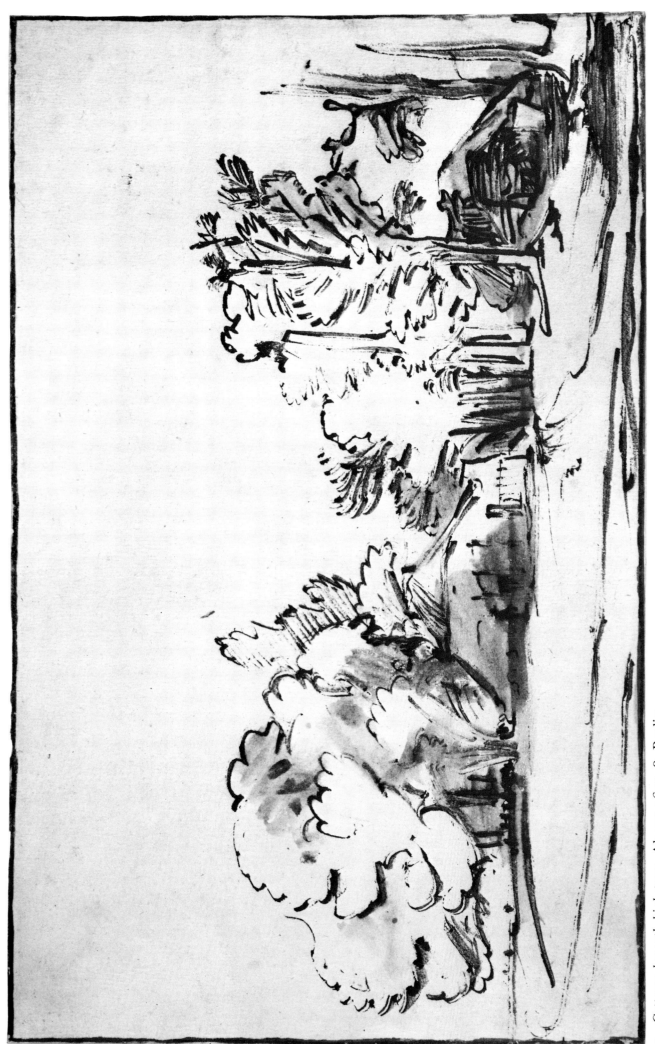

59. *Cottages beneath high trees.* About 1657–8. Berlin

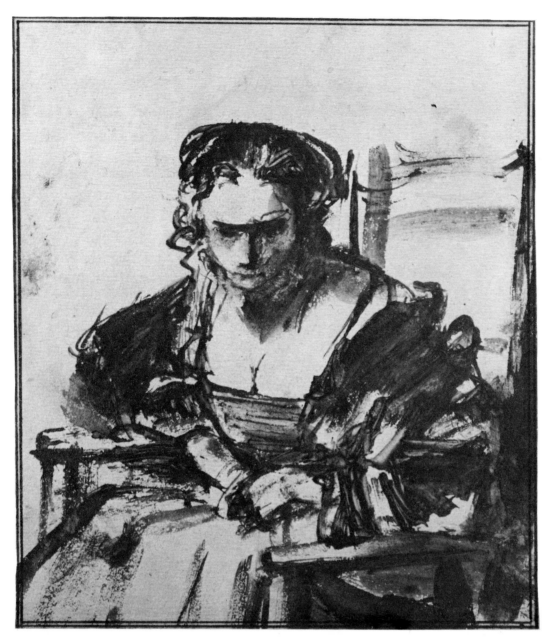

60. *Young woman seated in an armchair*. About 1655–6. London

Both these studies are characteristic of Rembrandt's style in the 1650s. The touch is bolder and more rugged, the details vividly suggested rather than laboriously described. The effect is monumental, weighty but not heavy. Plate 60 must represent Hendrickje, perhaps dressed in a sixteenth-century costume.

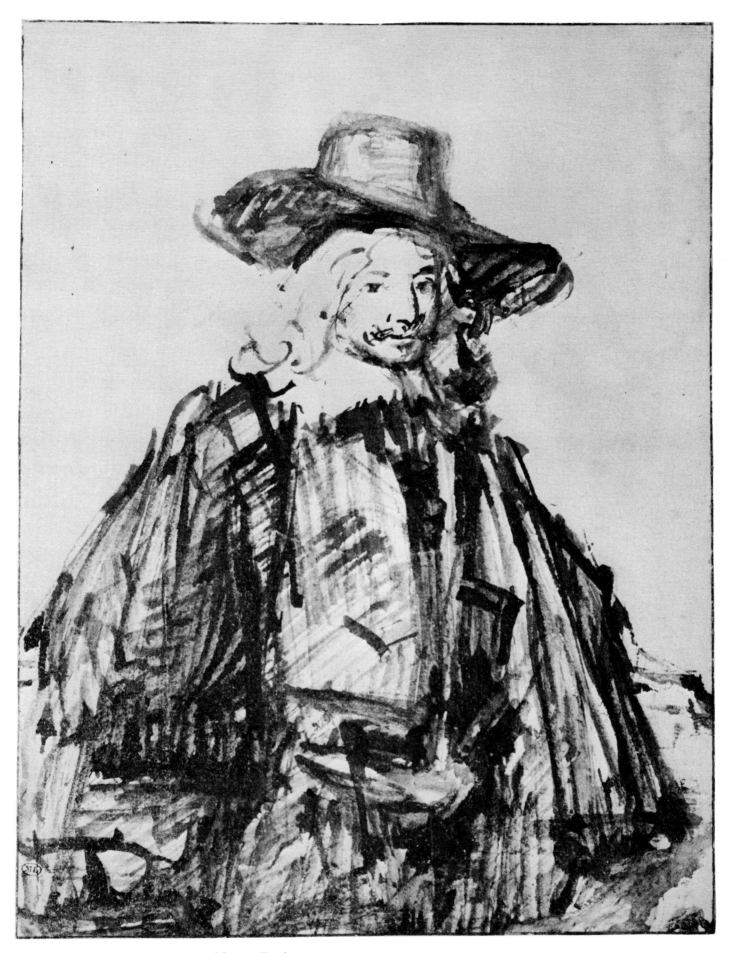

61. *Portrait of a man.* About 1662–5. Paris

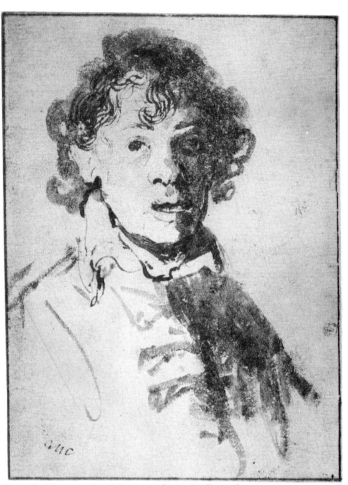

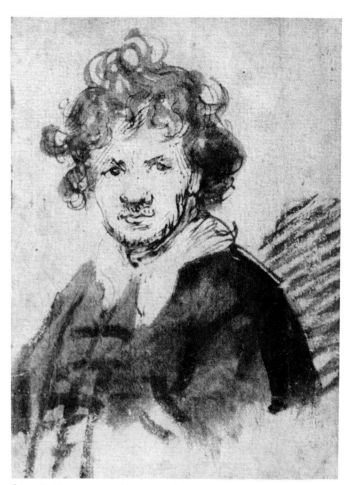

62. *Self-portrait*. About 1627–8. London

63. *Self-portrait*. About 1628–9. Amsterdam

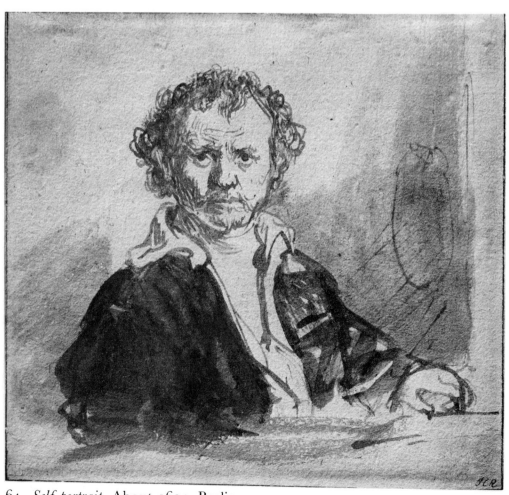

64. *Self-portrait*. About 1634. Berlin

Rembrandt drew, painted and etched his own features throughout his life. The last known self-portrait is dated 1669, the year of his death. The work constitutes an autobiography of unparalleled range and insight.

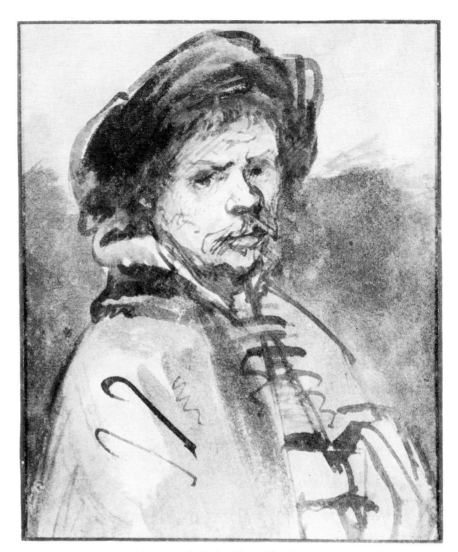

65. *Self-portrait*. About 1636–8. New York

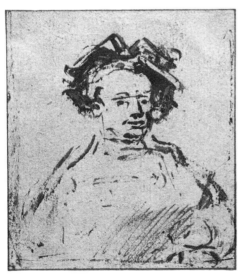

66. *Self-portrait*. About 1657–8. Rotterdam

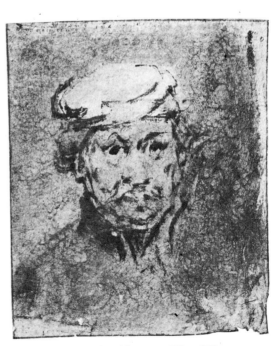

67. *Self-portrait*. About 1660. Vienna

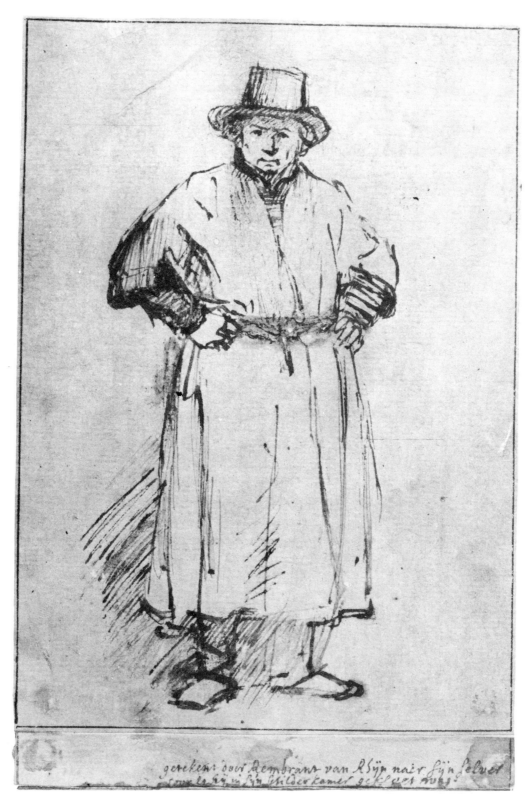

gereken: door Rembrant van Rhijn naer hijn felver
Loo als hij in hijn schilder kamer gekleet was.

68. *Self-portrait*. About 1655–6. Amsterdam